The Technique of
ETCHING

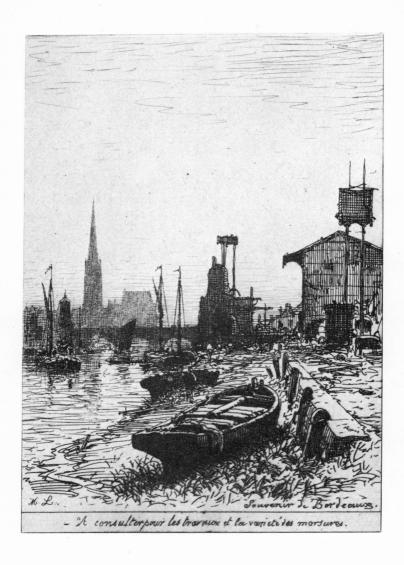

H. L.

Souvenir de Bordeaux.

— A consulter pour les travaux et la variété des morsures.

The Technique of
ETCHING

CRITIC

Maxime Lalanne

Translated by S. R. Koehler

Edited and with an Introduction by
Jay M. Fisher
Associate Curator, Prints, Drawings and Photographs,
The Baltimore Museum of Art

•

DOVER PUBLICATIONS, INC.
NEW YORK

Published in Canada by General Publishing Company, Ltd.,
30 Lesmill Road, Don Mills, Toronto, Ontario.
Published in the United Kingdom by Constable and Com-
pany, Ltd., 10 Orange Street, London WC2H 7EG.

This Dover edition, first published in 1981, is a republication
of the first American edition of the work as published by Dana
Estes and Company, Boston, in 1880, under the title *A Treatise
on Etching*. It has been supplemented and otherwise altered as
described in the Preface to the Dover Edition.

International Standard Book Number: 0-486-24182-3
Library of Congress Catalog Card Number: 81-67347

Manufactured in the United States of America
Dover Publications, Inc.
180 Varick Street
New York, N.Y. 10014

Preface to the Dover Edition

The first edition of Maxime Lalanne's *Traité de la Gravure à l'eau-forte* appeared in 1866, published by Cadart and Luquet in Paris. A second French edition appeared in 1878. This new Dover edition is a reprint of the first English-language edition, published in both Boston and London in 1880. The English translation by S. R. Koehler was based on the second French edition. The American and English editions originally included a preface, introduction (with two plates) and notes by Koehler, all of which largely contained information on American suppliers of materials and the like that is now obsolete. They have been omitted from the present edition and replaced by a new Introduction to the Dover Edition, which includes seven new illustrations. Retained from 1880 are a letter from the nineteenth-century critic and scholar Charles Blanc (1813–1882) and Lalanne's introduction to the second French edition of 1878. Lalanne's introduction to the 1866 edition, omitted in 1880, has been specially translated and included here for its historical interest. With one exception, the illustrative plates in the present volume are reproduced from the third French edition (no date; unchanged from the second), where they are much better printed than in the 1880 American edition; the exception is Plate Ia, which did not occur in the third French edition.

Sylvester Rosa Koehler (1837–1900), the 1880 translator, was the first curator of the print rooms of both the Smithsonian Institution in Washington, D.C., and the Museum of Fine Arts in Boston. During his career he published widely on printmaking, with a special sympathy for, and comprehension of, technical processes. His 1895 work, *Etching,* was both an important historical survey and an excellent technical review.

Koehler's remarkable commitment to contemporary American print-makers and his energetic struggle for the enhancement of public appreciation of the graphic arts made him one of the most important early print curators in this country. His professional achievements, coming at a time when the first study centers for prints were being established in America, remain a model for twentieth-century professionals. A short biographical notice on Koehler was recently published by Cynthia Clark, *Print Collector's Newsletter*, XI (July–August 1980), pp. 85–86.

J. M. F.

Introduction to the Dover Edition

by Jay M. Fisher

Lalanne's treatise on etching, in its methodical enumeration of the technical aspects of the medium, is useful as a handbook for the student or amateur. But it also expounds the artistic principles of Lalanne's approach to etching. Lalanne epitomized, in both his printmaking and writing, the much-discussed revival of etching in mid-nineteenth-century France, a revival that was to influence printmaking in Europe and America well into the twentieth century.

Maxime-François-Antoine Lalanne was born in Bordeaux on November 27, 1827. His father, a local government official, enrolled him in a public academy. The traditional classical education he was given there fortunately included a course in drawing. By 1848, when he received his degree in letters, his intended career of notary was abandoned in favor of pursuing an education as a draftsman, resulting, in 1850, in his first exhibition in the Bordeaux city hall. Shortly thereafter he moved to Paris and took up studies with the painter Jean Gigoux (1806–1894). Although Gigoux was known primarily as a historical painter in the romantic vein, his influence on Lalanne's drawing was in the area of landscape. By 1852 Lalanne had exhibited in one of the annual Salons for the first time, and continued to exhibit his drawings in the Salons until late in his life.[1] His fascination for the medium led him to write, in 1859 (seven years before he wrote his more famous manual on etching), the first treatise ever published on charcoal drawing.

[1] A recent exhibition catalogue of Lalanne drawings was written by John Taormina, *Maxime Lalanne: Drawings and Prints from The John Taylor Arms Collection of the College of Wooster,* Fine Arts Gallery, John Carroll University, Cleveland, Ohio, April 28–May 16, 1979.

The year 1863 marks Lalanne's debut as an etcher, with his striking *Rue des Marmousets*. This city view was one of several Lalanne made in the 1860s, all showing Paris at the time when Baron Haussmann's demolition of medieval streets was permanently changing the appearance of the city. These prints attracted a great deal of positive response from such critics as Paul Saint-Victor and Philippe Burty, greatly enhancing Lalanne's reputation. Burty was a protagonist in the "Renaissance of Etching" and his enthusiasm for Lalanne's prints put the artist at the forefront of that revival.

Lalanne's etchings of city scenes, carefully composed with stark contrasts in light and shade, are drawn with a precise line, responsive to architectural details and surface textures. Although the majority of his

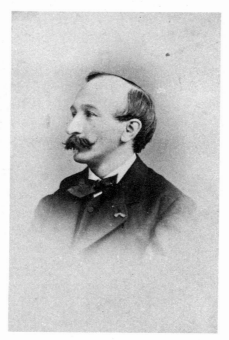

Fig. 1. Carte-de-visite photograph of Lalanne by Jules Trouvé, Paris. (All the figures in this Introduction are from The Baltimore Museum of Art: The George A. Lucas Collection, on indefinite loan from The Maryland Institute, College of Art.)

Fig. 2. Monument to Lalanne in Bordeaux.

prints reflect his preference for landscape, the subject he pursued most commonly in drawing and painting, ironically he was to become best known for his etched city views. These urban scenes document a vanishing Paris and suggest a revolution in social history. Like Charles Méryon (1821–1868), the other major figure in the early stages of the etching revival, Lalanne was not striving for an objective architectural view; both artists shared a decidedly romantic vision of the Parisian scenes they portrayed, although Lalanne lacked the taste for fantasy and the bizarre which makes Méryon's prints so memorable. Lalanne

was far more prolific than the short-lived Méryon and, taken as a whole, Lalanne's work shows little sign of variation or growth, lacking the vitality of Méryon's.

Lalanne was justly admired for his technical achievements, which set standards of excellence in an age of the amateur. Some of his prints are technically among the finest made in the mid-nineteenth century. But his work in general is that of a craftsman who never really displayed the spirited inventiveness of the creative artist. William Bradley said of Lalanne in an article of 1913: "He canalized his cleverness, and confined his virtuosity to overcoming the difficulties involved in a strict adherence to certain fixed rules of procedure."[2] Lalanne's etchings and the few lithographs that he made were widely exhibited, together with his equally admired drawings. He received many honors, including the first knighthood for an etcher, conferred by Ferdinand, King of Portugal, who reportedly benefited, like many others, from Lalanne's lessons on etching. After a decline in health during the last six years of his life, which severely limited his creative pursuits, Lalanne died at the age of fifty-eight in 1886.

In America, Lalanne's etchings were widely collected and were frequently exhibited in the New York galleries of Frederick Keppel. Owing to the exceptional enthusiasm for Lalanne's work on the part of two American collectors, two remarkable groups of his work are in the United States: one in Baltimore as part of the George A. Lucas Collection of The Maryland Institute, College of Art, on indefinite loan to The Baltimore Museum of Art, and the other as part of the Samuel P. Avery Collection in the New York Public Library.[3]

Historically, Lalanne's greatest contribution was his *Treatise on Etching*. It was scarcely the first treatise on the subject, but it was

[2] William Aspenwall Bradley, "Maxime Lalanne," *The Print Collector's Quarterly*, 3 (1913), p. 72. There is no adequate biographical work or catalogue raisonné on Lalanne; the best to date is a small pamphlet published in France (Charles Marionneau, *Lalanne*, Bordeaux, 1886), an extract from *Gironde littéraire et scientifique*, August 29, 1886.

[3] Both of these collections contain important proofs undescribed in existing listings of Lalanne prints. The Lucas Collection also contains a rare painting by Lalanne.

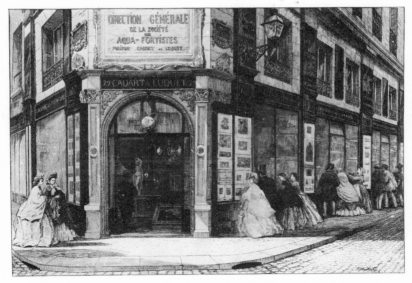

Fig. 3. Entrance to the Société des Aquafortistes, Paris (etching by
Martial, ca. 1864).

unique for its time in its careful and methodical explanation of the
medium. Its informal language, using nontechnical terms, made it ac-
cessible to the amateur and professional alike. The exposition used most
widely before Lalanne's, one of the first ever published, was *De la gra-
vure en taille-douce, à l'eau-forte et au burin* by Abraham Bosse (1602–
1675). This account, originally published in 1645, was reprinted in re-
vised editions in 1701, 1745 and 1758. Bosse ignored Rembrandt's
achievements in favor of Jacques Callot's, and relegated etching to a
subservient role in favor of engraving. The etchers most admired by
Bosse were those who made their etchings look like engravings. A 1758
edition of Bosse revised by Nicholas Cochin (1715–1790) redressed
this bias; Cochin's defense of the true values of etching can be seen as
an early argument for the role etching would assume in the nineteenth
century. In the early decades of that century, when a few important
artists began to take up etching, a number of articles appeared on the
medium in encyclopedias and small manuals. The first work which

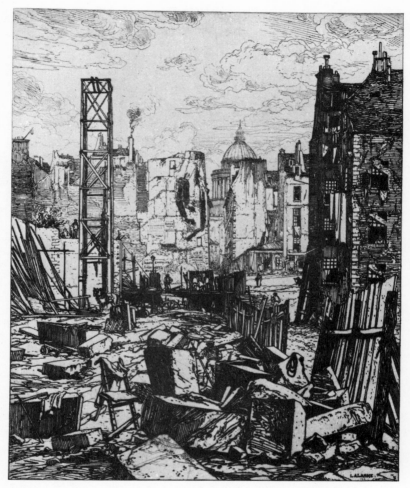

Fig. 4. "Demolition for Cutting Through the Boulevard Saint-Germain" (etching by Lalanne, ca. 1864).

really capitalized on the explosion of interest in etching, marked by the founding of the Société des Aquafortistes in 1862, was a charming exposition designed and printed on copper plates by Martial Potément (1828–1883) in 1864. It was entitled *Lettre de Martial sur les éléments de la gravure à l'eau-forte*. Lalanne followed in 1866 with the first com-

prehensive discussion of etching published during the height of the revival. The Lalanne treatise was published by the director of the Société des Aquafortistes, Alfred Cadart (1828–1875), a tireless entrepreneur of the medium. The publication was crucial to the commercial life of the organization since Cadart could supply the amateur with all the necessary materials described in Lalanne's book, including a small and supposedly portable press. Cadart was interested in promoting the use of etching by painters and professional printmakers as well as amateurs, for his financial success depended on a wider public. In fact, the Société dissolved after five years, but Lalanne contributed perhaps more than any other individual to whatever success it enjoyed.[4] His book sold widely and was universally admired as a guide for etchers. It is amusing to note that Lalanne was not above a little commercial promotion in his prints: mounted on some of the buildings in Lalanne's early city views are placards advertising Cadart's enterprises and even the treatise itself.

Although many other treatises were to follow with expositions of more complicated etching procedures, Lalanne's stands in the forefront of the etching revival, which peaked in the decade of its publication. The revival had its beginnings with Barbizon artists such as Charles Jacque (1813–1894), Charles Daubigny (1817–1878) and Camille Corot (1796–1875), who took their printing plates outdoors in an effort to capture more sensitively the effects of nature. With the encouragement of critics such as Charles Baudelaire (1821–1867) and Théophile Gautier (1811–1872), artists gravitated to etching in increasing numbers during the 1840s and 1850s. Etching was widely praised as the most effective medium for transmitting the true feeling and personality of the artist, in that it supposedly allowed a spontaneous expression unencumbered by the strict rules of the academic approach to engraving.

The Lalanne treatise is written as an informal lecture to a beginning student struggling with his first plate as we look over his shoulder. The

[4] The most comprehensive work on the Société is Janine Bailly-Herzberg, *L'eauforte de peintre au dix-neuvième siècle—La Société des Aquafortistes, 1862–1867*, Paris, 1972, 2 vols.

text progresses through the preparation and printing of the plate, with careful explanations at each stage for the imaginary student. In the first edition of the treatise Lalanne was much more historical, frequently mentioning contemporaries who used a particular technique with great effectiveness. The second edition, on which this translation is based, is somewhat shorter and more simply expressed, without references to the work of other artists. Koehler's translation is fairly accurate, but might not be universally approved today for its liberties with language. Koehler invented numbered chapters by dividing Lalanne's text on the basis of suggested section titles included in his margins. This device gives the material a more systematic structure than characterizes the original and compromises the flow of Lalanne's language. As Koehler intended, however, it does make the treatise more manageable as a reference tool.

In his treatise, particularly in the first chapter on the "Definition and Character of Etching,"[5] Lalanne discusses a number of aesthetic issues

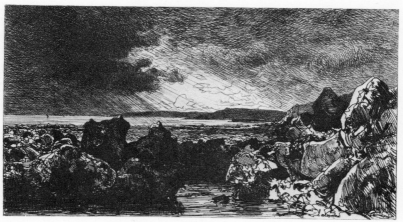

Fig. 5. "[Rocks by the Sea]" (etching by Lalanne).

reflecting his own particular attitudes, which closely parallel much of the critical opinion expressed in the 1860s about etching. Lalanne believed that a printmaker must have a clear conception of his artistic idea

[5] Lalanne, pp. 3–8.

before he begins and that his technique must always harmonize with his subject. Lalanne appeals for freshness and neatness (clearly describing his own etching). His careful and preconceived approach distinguishes him from later practitioners of etching such as Buhot, Pissarro

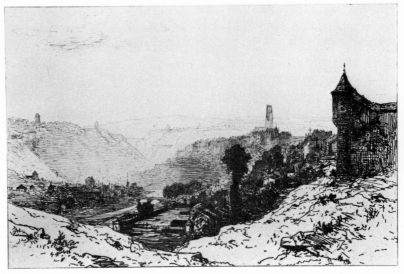

Fig. 6. "View of Fribourg" (unfinished early state of etching by Lalanne, ca. 1870).

and Degas, who left more to chance and were decidedly experimental in their art. Although the conservative Lalanne was precise in his vision and almost mathematical in his method, he fully realized that etching should be free and "capricious" in contrast to the "severity and coldness" of the engraver's art.[6] He believed in the simplicity and natural grace of the etching needle, and viewed the acid as providing the warmth of life. Although Lalanne acknowledged that many artists were successful in making etched copies of other works of art (reproductive etching) and that this could be an important aspect of etching (previously done only with engraving), he encouraged originality as a higher pursuit.

In a review of 1862, Charles Baudelaire commented on the capacity

[6] Lalanne, p. 4.

of etching to transmit the artist's personality; Lalanne agreed, suggesting that it was possible for the individuality of an artist to be so apparent that the process almost disappears.[7] Lalanne cited Rembrandt as an excellent example, noting that the artist's style was so powerful that it submerged issues of technique. Lalanne himself actually preferred the etchings of Claude Lorrain, an artist to whom he was frequently compared, for Claude "knew how to conciliate freedom of execution with majesty of style."[8] In Lalanne's own prints the process very much dominated. For Lalanne, etching was not, as in the eighteenth century, "a secondary method"; he wrote: "There are no secondary methods for the manifestation of genius."[9]

Technically, Lalanne was an etching purist and he believed every desired effect could be achieved by the etching needle in concert with sensitive printing technique. He did not favor other techniques frequently used in tandem with etching, such as aquatint, drypoint and roulette, as well as engraving. He rejected roulette, extremely popular in the nineteenth century, as unnecessary;[10] he considered drypoint permissible for rectifying a minor failure in an etched line,[11] but gave it no credence as a technique with intrinsic value; and he did not even discuss aquatint. Lalanne does mention the use of sulphur tint for the achievement of slight areas of tone,[12] but he clearly prefers line. He avers that textures, linear details and the ability to suggest distances, near and far, can all be achieved with the etching tool.

There are very few technical details that will perplex the contemporary reader, especially one moderately familiar with etching technique. Lalanne describes the use of nitric acid instead of the Dutch mordant

[7] Charles Baudelaire, *Art in Paris, 1845–1862* (ed. and tr. by Jonathan Mayne), London, 1965. This article, originally from *Le Boulevard*, September 1862, derives from a shorter article, entitled "L'eau-forte est à la mode," from *Revue Anecdotique*, April 1862.

[8] Lalanne, p. 6.

[9] Lalanne, p. 7.

[10] Lalanne, p. 49.

[11] Lalanne, pp. 32–33, 53–54.

[12] Lalanne, p. 50.

which is used today. He proposes smoking to darken the ground so that the mark of the needle can be seen against the copper. He describes etching needles of various widths as helpful for achieving a variety of etched lines of different size and character, but he seems to prefer the use of stop-out varnishes as a better method to hold back an etched line so it will appear thinner and lighter, as required for backgrounds. Lalanne offers excellent advice about retouching the plate to re-etch unsatisfactory lines in the final stages of biting. He mentions a technique somewhat novel for this period, in which acid is brushed directly on the plate without the benefit of a ground. Today this is known as spit-biting. He discusses a lift-ground method in which the ground is applied over pen lines to give an effect approximating the appearance of a drawing.[13] This innovative technique was used effectively by Félix Bracquemond (1833–1917), who, after Lalanne, was the most admired master of etching techniques during the early revival. Before giving directions on

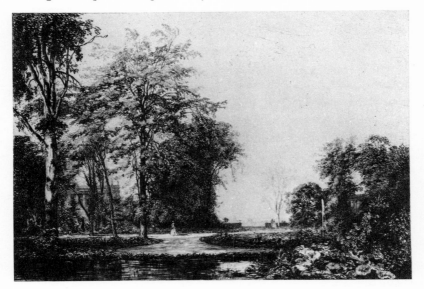

Fig. 7. "On the Outskirts of Paris [A Park]" (etching by Lalanne).

[13] Lalanne, p. 54.

the proofing and printing of the plate, the third creative stage after drawing and biting, Lalanne provides a welcome diversion with a discussion of many of the accidents that can befall the beginning etcher.[14]

Much as in printmaking of our own time, the printing workshop was a major factor in the nineteenth century, and comparatively few artists actually bothered with their own printing. Lalanne recommends that the artist do his own printing, or at least work very closely with the master printer. He writes that "the artist and the printer are merged into each other,—the printer losing himself in the artist . . . and the artist giving way to the printer, to avail himself of his practical experience."[15] Lalanne distinguishes two approaches to printing which effectively characterize the two divergent attitudes toward printing in the later nineteenth century. The first is "natural printing," in which the plate is cleanly wiped and the lines stand on their own, and the second is "artificial printing," where in certain areas a film of ink is left on the plate to achieve a tone and enrich the lines.[16] Lalanne's own etching charts a middle course: generally the plates are very cleanly wiped, although "retroussage" is used in some areas to work ink out of the lines, thereby adding a slight tone to enrich and darken a particular line or area of closely spaced lines. Printers such as Auguste Delâtre (1822–1907) would later systematically develop the use of heavy plate tone, but from the 1870s on, the creative use of interpretive inking led to a fascination with the monotype.[17] It is notable that Lalanne was aware of these issues, and his discussion of the various aspects of printing undoubtedly encouraged many artists to experiment with varieties of printing in their own etchings.

For the contemporary reader, Lalanne's treatise remains an important document in the history of the practice of etching, particularly

[14] Lalanne, pp. 37–42.
[15] Lalanne, pp. 56–57.
[16] Lalanne, pp. 56–57.
[17] The issue of printing techniques in the nineteenth century is discussed by Eugenia Parry Janis, "Setting the Tone/ The Revival of Etching/ The Importance of Ink," *The Painterly Print,* exhibition catalogue, The Metropolitan Museum of Art, New York, 1980, pp. 9–28.

during its great revival in nineteenth-century France. The wide use of the treatise by etchers in England and America is also an important aspect of the history of etching in both countries. Many etchers on the contemporary printmaking scene, in search of almost forgotten techniques, have been drawn toward the achievements of the nineteenth-century artists. Lalanne's treatise provides numerous insights into processes followed by these early etchers, whose experiments are not without relevance to the contemporary artist. The clarity and informality of Lalanne's explanations should be welcome to the reader who has struggled with many overly technical discussions of the medium. In both his writing and his printmaking, Maxime Lalanne spoke with a clear voice and saw with an uncomplicated vision, leaving very little to chance.

Introduction to the First French Edition (1866)

by Maxime Lalanne

The impetus given to the art of etching since the foundation of the Société des Aquafortistes has led many artists and amateurs desirous of making a name in the field to look into the various procedures involved. Few treatises have been written on the practice of this art, which is unconnected with other types of printmaking. The one by Abraham Bosse[1] deals especially with etching used in combination with burin work; the volume also contains formulas for preparing on one's own the substances needed for varnishing and biting; today we get them already prepared by the chemists.

At that time etching acid was a special compound, now replaced by azotic acid, commonly called nitric acid; biting was done only by pouring; hard varnish and soft varnish were used. Nowadays the former is no longer used; the second constitutes ordinary modern varnish, and the application of present-day soft varnish was not known.

Moreover, it is probable that Bosse, although a contemporary of Rembrandt, was unaware, at the time his book appeared, of the results obtained in etching by that great master, whom he does not mention, and from whose experiences he could have borrowed a wider knowledge of the physical procedures.

In the reign of Louis XV, Cochin, inventor of the varnish commonly used now, continued Bosse's treatise.

[1] *De la gravure en taille-douce, à l'eau-forte et au burin, ensemble la manière d'en imprimer les planches et d'en construire la presse,* par Abraham Bosse, Paris, 1645.

Traité des manières de graver en taille-douce sur l'airain par le moyen des eaux-fortes et des vernis durs et mols, par le s. Abraham Bosse, augmenté de la nouvelle manière dont se sert M. Leclerc, graveur du Roy. Paris, M.DCC.I.

There are some very well written modern treatises, but they contain only the rudiments of the subject; up to now the personal experience of some individual artists has done all the rest. In a pleasing spirit of fellowship, they have not refused to allow others the advantage of their own knowledge; they have understood that it was in the interest of everyone to disseminate what was known about this art and thus to make manifest to a greater number of art lovers, accustomed to the splendors of older prints, the true resources and importance of contemporary etching, represented by names which are not numerous, it is true, but which will be famous in their turn.

The tendencies of modern art seem to favor the more complete flowering of a medium that lends itself particularly to the picturesque, and was little suited to the nature of art at the beginning of this century. Its more prolific expansion in our generation will surely fill the long gap that thus arose in the history of painter-printmakers.

The impulse was given and followed; Cadart and Luquet are to be thanked for taking the initiative by lending artists this material aid and giving their isolated efforts the form of an institution; with well-directed energy they are seconding this new-born manifestation. Encouraged by the warmest good wishes, they are working with faith and perseverance for the regeneration of etching, but not without struggling against many difficulties. The labors of the Société des Aquafortistes are daily satisfying the most demanding. The movement is contagious and is gradually spreading to the greatest painters. Two royal artists, Dom Fernando of Portugal and the King of Sweden, have deigned to join it. A princess who is helping to uphold the honor of the arts among us through her personal participation—Princess Mathilde—is also interested in this renaissance, the idea of which is developing and broadening. I hope I may contribute a small share myself by taking the liberty of transmitting to others the practical notions I have acquired through experience or gathered from the valuable communications of the artists of whom I have spoken.

Introduction to the Second French Edition (1878)

by Maxime Lalanne

SINCE the year 1866, when the first edition of this treatise appeared, the art of etching, which was then in full course of regeneration, has gained considerably in extent. The tendencies of modern art must necessarily favor the soaring flight of this method of engraving, which has been left in oblivion quite too long. It remained for our contemporary school to accord to it those honors which the school of the first empire had denied to it, and which that of 1830 had given but timidly. At the period last named some of our illustrious masters, by applying their talent to occasional essays in etching, set an example which our own generation, expansive in its aspirations, and anxiously desirous of guarding the rights of individuality, was quick to follow.

The *Gazette des Beaux Arts* comprehended this movement, and contributed to its extension by attracting to itself the artists who rendered themselves illustrious by the work done for its pages, while, by a sort of natural reciprocity, they shed around it the prestige of their talents. The *Société des Aqua-fortistes* (Etching Club), founded in 1863 by Alfred Cadart, has also, by the united efforts of many eminent etchers, done its share towards bringing the practice of this art into notice, and has popularized it in the world of amateurs, whose numbers it has been instrumental in augmenting ; while at the same time, owing to the nature of its constitution, it has given material support to the artists. Private collections have been formed, and are growing in richness from day to day. Two royal artists, King Ferdinand of Portugal and King Charles XV. of Sweden, have,

through their works, taken an active part in the renewal of etching ; they were the happy sponsors of a publication which, under the name of *L'Illustration Nouvelle*, follows in the footsteps, and continues the traditions, of the *Société des Aqua-fortistes*.

Similar societies, organized in England and in Belgium,[1] are prospering. On the other hand, a great number of art journals, of books, and of albums, owe their success to the use made in them of etchings. This is true also of those special editions which are sumptuously printed in small numbers, and are the delight of lovers of books.

Etching has thus taken a position in modern art which cannot fail to become still more important. "Everything has been said," wrote La Bruyère, concerning the works of the pen, "and we can only glean after the poets." The literature of two centuries has given the lie to the assertion of the celebrated moralist, and it may also be affirmed that etching has not yet spoken its last word. Not only has it no need of gleaning after the old masters, but it may rather seek for precious models in the works of our contemporary etchers. In their experience may be found fruit for the present as well as useful information for the future.

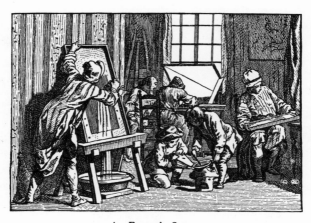

AN ETCHER'S STUDIO.

From the Third Edition of Abraham Bosse's "Treatise," Paris, 1758.

Letter From Charles Blanc

MY DEAR MONSIEUR LALANNE,*

If there is any one living who can write about Etching, it must certainly be you, as you possess all the secrets of the art, and are versed in all its refinements, its resources, and its effects. Nevertheless, when I was told that you intended to publish a book on the subject, I feared that you were about to attempt the impossible ; for it seemed as if Abraham Bosse had exhausted the theme two hundred years ago, and that you would be condemned to repeat all that this excellent man had said in his treatise, in which, with charming *naïveté*, he teaches *the art of engraving to perfection.*

I must confess, however, that the reading of your manuscript very quickly undeceived me. I find in it numberless useful and interesting things not to be found anywhere else, and I comprehend that Abraham Bosse wrote for those who know, while you write for those who do not know.

I was quite young, and had just left college, when accident threw into my hands the *Traité des manières de graver en taille douce sur l'airain par le moyen des eaux fortes et des vernis durs et mols.* Perhaps I might have paid no attention to this book, if I had not previously noticed on the stands on the *Quai Voltaire* some etchings by Rembrandt, which had opened to me an entirely new world of poetry and of dreams. These prints had taken such hold upon my imagination that I desired to learn, from Bosse's " Treatise," how the Dutch painter had managed to produce his strange and startling effects and his mysterious tones,

* This letter appeared in each French edition.

the fantastic play of his lights and the silence of his shadows. Rembrandt's etchings on the one hand, and Bosse's book on the other, were the causes of my resolution to learn the art of engraving, and of my subsequent entry into the studio of Calamatta and Mercuri.

As soon as I knew how to hold the burin and the point, these grave and illustrious masters placed before me an allegorical figure engraved by Edelinck, whose drapery was executed in waving and winding lines, incomparable in their correctness and beauty. To break my hand to the work, it was necessary to copy on my plate these solemnly classical and majestically disposed lines. But while I cut into the copper with restrained impatience, my attention was secretly turned towards Rembrandt's celebrated portrait of Janus Lutma, a good impression of which I owned, and which I thought of copying.

To make my *début* in this severe school — in which we were allowed to admire only Marc Antonio, the Ghisis, the Audrans, and Nanteuil — with an etching by Rembrandt, would have been a heresy of the worst sort. Hence to be able to risk this infraction of discipline, I took very good care to keep my project to myself. Secretly I bought ground, wax, and a plate, and profited of the absence of my teachers to attempt, with fevered hands, to make a fac-simile of the Lutma. I had followed the instructions of Abraham Bosse with regard to the ground, and I proceeded to bite in my plate with the assistance of a comrade, Charles Nördlinger, at present engraver to the king of Wurtemburg, at Stuttgart, whom I had admitted as my accomplice in this delightful expedition.

You may well imagine, my dear Monsieur Lalanne, that I met with all sorts of accidents, such as are likely to befall a novice, and all of which you describe so carefully, while at the same time you indicate fully and lucidly the remedies that may be applied. The ground cracked in several places, — happily in the dark

parts. My wax border had been hastily constructed, and I did
not know then, although Bosse says so, that it is the rule to pass
a heated key along the lower line of the border, so as to melt the
wax, and thus render all escape impossible. Consequently the
acid filtered through under the wax, and in trying to arrest
the flow, I burned my fingers. Furthermore, when it came to the
biting in of the shadows in the portrait of Lutma, the greenish
and then whitish ebullition produced by the long-continued
biting so frightened me, that I hastened to empty the acid into
a pail, not, however, without having spattered a few drops on a
proof of the *Vow of Louis XIII.*, which had been scratched in the
printing, and which we were about to repair. At last I removed
the ground, and, trembling all over, went to have a proof taken,
but not to the printer regularly employed by Calamatta.

What a disappointment! I believed my etching to have been
sufficiently, nay, even over bitten, and in reality I had stopped
half-way. The color of the copper had deceived me. I had seen
my portrait on the fine red ground of the metal, and now I saw
it on the crude white of the paper. I hardly knew it again. It
lacked the profundity, the mystery, the harmony in the shadows,
which were precisely what I had striven for. The plate was only
roughly cut up by lines crossing in all directions, through the net-
work of which shone the ground which Rembrandt had subdued,
so as to give all the more brilliancy to the window with its leaded
panes, to the lights in the foreground, and to the cheek of the
pensive head of Lutma. As luck would have it, all the light part
in the upper half of the print came out pretty well; the expres-
sion of the face was satisfactory, and the grimaces of the two
small heads of monsters which surmount the back of the chair
were perfectly imitated. I had to strengthen the shadows by
means of the roulette, and to go over the most prominent folds
of the coat with the graver; for I had not the knowledge neces-
sary to enable me to undertake a second biting. Bosse says a

few words on this subject, which, as they are wanting in clearness, are apt to lead a beginner into error. He speaks of smoked ground, while, as you have so admirably shown, white ground must be used for retouching. I therefore finished my plate by patching and cross-hatching and stippling, and finally obtained a passable copy, which, at a little distance, looked something like the original, although, to a practised eye, it was really nothing but a very rude imitation. It is needless to say that we carefully obliterated all evidence of our proceedings, and that, my teachers having returned, I went to work again, with hypocritical compunction, upon what I called the *military* lines of Gerard Edelinck. But we were betrayed by some incautious words of the chamberwoman, and M. Calamatta, having discovered "the rose-pot," scolded Charles Nördlinger and myself roundly for this romantic escapade. If my plate had been worse, —— the good Lord only knows what might have happened !

All this, my dear M. Lalanne, is simply intended to show to you how greatly I esteem the excellent advice which you give to the young etcher, or *aqua-fortiste* (as the phrase goes now-a-days, according to a neologism which is hardly less barbaric than the word *artistic*). When I recall the efforts of my youth, the ardor with which I deceived myself, the hot haste with which I fell into the very errors which you point out, I understand that your book is an absolute necessity ; and that the artist or the amateur, who, hidden away in some obscure province, desires to enjoy the agreeable pastime of etching, need only follow, step by step, the intelligent and methodical order of your precepts, to be enabled to carry the most complicated plate to a satisfactory end, whether he chooses to employ the soft ground used by Decamps, Masson, and Marvy, or whether he confines himself to the ordinary processes which you make sensible even to the touch with a lucidity, a familiarity with details, and a certainty of judgment, not to be sufficiently commended.

Having read your "Treatise," I admit, not only that you have surpassed your worthy predecessor, Abraham Bosse, but that you have absolutely superseded his book by making your own indispensable. If only the amateurs, whose time hangs heavily upon them ; if the artists, who wish to fix a fleeting impression ; if the rich, who are sated with the pleasures of photography, — had an idea of the great charm inherent in etching, your little work would have a marvellous success ! Even our elegant ladies and literary women, tired of their do-nothing lives and their nicknacks, might find a relaxation full of attractions in the art of drawing on the ground and biting-in their passing fancies. Madame de Pompadour, when she had ceased to govern, although she continued to reign, took upon herself a colossal enterprise, — to amuse the king and to divert herself. You know the sixty-three pieces executed by this charming engraver (note, if you please, that I do not say *engraveress !*). Her etchings after Eisen and Boucher are exquisite. The pulsation of life, the fulness of the carnations, are expressed in them by delicately trembling lines ; and I do think that Madame de Pompadour could not have done better, even if she had been your pupil.

At present, moreover, etching has, in some measure, become the fashion again as a substitute for lithography, an art which developed charm as well as strength under the crayon of Charlet, of Géricault, of Gigoux, and of Gavarni. The *Société des aquafortistes* is the fruit of this renaissance. The art, which, in our own daý, has been rendered illustrious by the inimitable Jacque, now has its adepts in all countries, and in all imaginable spheres of society. Etchings come to us from all points of the compass : the Hague sends those of M. Cornet, conservator of the Museum ; Poland, those which form the interesting album of M. Bronislas Zaleski, the *Life of the Kirghise Steppes ;* London, those of M. Seymour Haden, so original and full of life, and so well described in the catalogue of our friend Burty ; Lisbon, those of King Fer-

dinand of Portugal, who etches as Grandville drew, but with
more suppleness and freedom. But after all Paris is the place
where the best etchings appear, more especially in the *Gazette
des Beaux-Arts,* and in the publications of the *Société des Aqua-
fortistes.* Do you desire to press this capricious process into
your service for the translation of the old or modern masters?
Hédouin, Flameng, Bracquemont, will do wonders for you. You
have told me yourself that, in my *Œuvre de Rembrandt,* Flameng
has so well imitated this great man, that he himself would be
deceived if he should come to life again. As to Jules Jacque-
mart, he is perfectly unique of his kind; he compels etching to
say what it never before was able to say. With the point of his
needle he expresses the density of porphyry; the coldness of
porcelain; the insinuating surface of Chinese lacquer; the trans-
parent and imponderable *finesse* of Venetian glassware; the
reliefs and the chased lines of the most delicate works of the gold-
smith, almost imperceptible in their slightness; the polish of iron
and steel; the glitter, the reflections, and even the sonority of
bronze; the color of silver and of gold, as well as all the lustre
of the diamond and all the appreciable shades of the emerald, the
turquoise, and the ruby. I shall not speak of you, my dear mon-
sieur, nor of your etchings, in which the style of Claude is so well
united to the grace of Karel Dujardin. You preach by prac-
tising; and if one had only seen the plates with which you have
illustrated your excellent lessons, one would recognize not only
the instructor but the master. Hence, be without fear or hesita-
tion; put forth confidently your little book; it is just in time to
help regenerate the art of etching, and to direct its renaissance.
For these reasons — mark my prediction! — its success will be
brilliant and lasting.

Contents

———◆———

CHAPTER I.

CHAPTER II.

CHAPTER III.

BITING.

CHAPTER IV.

FINISHING THE PLATE.

CHAPTER V.

ACCIDENTS.

CHAPTER VI.

DIFFERENCE BETWEEN FLAT BITING AND BITING WITH STOPPING OUT.

CHAPTER VII.

RECOMMENDATIONS AND AUXILIARY PROCESSES. — ZINK AND STEEL PLATES. — VARIOUS THEORIES.

A. Recommendations and Auxiliary Processes.

CHAPTER VIII.

PROVING AND PRINTING.

Description of the Plates

PLATE I *a*. *Etching after Claude Lorrain. Unfinished plate,* or " first state " (see pp. 23 and 29). This, however, is not the etching itself ; it is a photo-engraving from the unfinished etching. But it does well enough to show the imperfections alluded to by M. Lalanne in the text. (facing p. 22)

PLATE I. *Etching after Claude Lorrain. Finished plate,* or " second state " (see pp. 36 and 56). Clean wiped. (facing p. 36)

PLATE II. *Etching after Claude Lorrain.* Printed from the same plate as Pl. I, but treated as described on p. 57. The difference between the two plates shows what the art of the printer can do for an etching. The difference would be still greater if Pl. II. were better printed ; for it is not printed as well as it might be, although it was done in Paris. (facing p. 38)

PLATE III. *À plat, une pointe* — flat biting, drawn with one point; that is to say, the plate was immersed only once, and the lines are all the result of the same needle, so that the effect is only produced by placing the lines close together in the foreground, and farther apart as the distance recedes (see p. 43). *À plat, plusieurs pointes* — flat biting, several points, that is to say, one immersion only, but the work of finer and coarser points is intermingled in the drawing. *Par couvertures, plusieurs pointes* — stopping out and the work of several points combined. (facing p. 43)

PLATE IV. *Fig.* 1. See p. 27. *Fig.* 2. See p. 45. *Figs.* 3, 4 *and* 5. See p. 46. (facing p. 46)

PLATE V. *Fig.* 1. Worked with one point ; effect produced by stopping out (see p. 44). *Fig.* 2. Mottled tint in the building, &c., in the foreground ; stopping out before biting, in the sky (see p. 51). (facing p. 50)

PLATE VI. *Soft-ground etchings.* See p. 52. (facing p. 52)

PLATE VII. *Dry-point etching.* See p. 53. (facing p. 54)

PLATE VIII. *À Séville.* A sketch, given as a specimen of printing (see p. 58). (facing p. 58)

PLATE IX. *À Anvers. Le Haag, Amsterdam.* Sketches from nature, to serve as examples. (facing p. 60)

PLATE X. (Frontispiece). *Souvenir de Bordeaux.* To be consulted in regard to the manner of using the points and partial bitings.

The Technique of
ETCHING

CHAPTER I.

DEFINITION AND CHARACTER OF ETCHING.

1. Definition. — An etching is a design fixed on metal by the action of an acid. The art of etching consists, in the first place, in drawing, with a *point* or *needle*, upon a metal plate, which is perfectly polished, and covered with a layer of varnish, or ground, blackened by smoke ; and, secondly, in exposing the plate, when the drawing is finished, to the action of nitric acid. The acid, which does not affect fatty substances but corrodes metal, eats into the lines which have been laid bare by the needle, and thus the drawing is *bitten in.* The varnish is then removed by washing the plate with spirits of turpentine, and the design will be found to be engraved, as it were, on the plate. But, as the color of the copper is misleading, it is impossible to judge properly of the quality of the work done until a *proof* has been taken.

2. Knowledge needed by the Etcher. — The aspirant in the art of etching, having familiarized himself by a few trials with the appearance of the bright lines produced by the needle on the dark ground of smoked varnish, will soon go to work on his plate confidently and unhesitatingly ; and, without troubling himself much about the uniform appearance of his work, he will gradually learn to calculate in advance the conversion of his lines into lines more or less deeply bitten, and the change in appearance which these lines undergo when transferred to paper by means of ink and press.

It follows from this that the etcher must, from the very beginning of his work, have a clear conception of the idea he intends

to realize on his plate, as the work of the needle must harmonize with the character of the subject, and as the effect produced is finally determined by the combination of this work with that of the acid.

The knowledge needed to bring about these intimate relations between the needle, which produces the *drawing*, and the biting-in, which supplies the *color*, constitutes the whole science of the etcher.

3. **Manner of Using the Needle. — Character of Lines. —** The needle or point must be allowed to play lightly on the varnish, so as to permit the hand to move with that unconcern which is necessary to great freedom of execution. The use of a moderately sharp needle will insure lines which are full and nourished in the delicate as well as in the vigorous parts of the work. We shall thus secure the means of being simple. Nor will it be necessary to depart from this character even in plates requiring the most minute execution ; all that is required will be a finer point, and lines of a more delicate kind. But the spaces left between the latter will be proportionately the same, or perhaps even somewhat wider, so as to prevent the acid from confusing the lines by eating away the ridges of metal which are left standing between the furrows. Freshness and neatness depend on these conditions in small as well as in large plates.

4. **Freedom of Execution. —** It is a well-known fact that the engraver who employs the burin (or graver), produces lines on the naked copper or steel which cross one another, and are measured and regular. It is a necessary consequence of the importance of line-engraving, growing out of its application to classical works of high style, that it should always show the severity and coldness of positive and almost mathematical workmanship. With etching this is not the case : the point must be free and capricious ; it must accentuate the forms of objects without stiffness or dryness, and must delicately bring out the various distances, without following any other law than that of a picturesque harmony in the execution. It may be made to work with precision, whenever that is needed, but only to be abandoned afterwards to its natural grace. It will be well, however, to avoid over-excitement and violence in execution, which give an air of slovenliness to that which ought to be simply a revery.

5. **How to produce Difference in Texture.** — The manner of execution to be selected must conform to the nature of the objects. This is essential, as we have at our disposition only a point, the play of which on the varnish is always the same. It follows that we must vary its strokes, so as to make it express difference in texture. If we examine the etchings of the old masters, we shall find that they had a special way of expressing foliage, earth, rocks, water, the sky, figures, architecture, &c., without, however, making themselves the slaves of too constraining a tradition.

6. **The Work of the Acid.** — After the subject has been drawn on the ground, the acid steps in to give variety to the forms which were laid out for it by the needle, to impart vibration to this work of uniform aspect, and to inform it with the all-pervading warmth of life. In principle, a single biting ought to be sufficient ; but if the artist desires to secure greater variety in the result by a succession of partial bitings, the different distances may be made to detach themselves from one another by covering up with varnish the parts sufficiently bitten each time the plate is withdrawn from the bath. The different parts which the mordant is to play must be regulated by the feeling : discreet and prudent, it will impart delicacy to the tender values ; controlled in its subtle functions, it will carefully mark the relative tones of the various distances ; less restrained and used more incisively, it will dig into the accentuated parts and will give them force.

7. **The Use of the Dry Point.** — If harmony has not been sufficiently attained, the *dry point* is used on the bare metal, to modify the values incompletely rendered, or expressed too harshly. Its office is to cover such insufficient passages with a delicate tint, and to serve, as Charles Blanc has very well expressed it, as a *glaze* in engraving.

8. **Spirit in which the Etcher must work.** — Follow your feeling, combine your modes of expression, establish points of comparison, and adopt from among the practical means at command (which depend on the effect, and on which the effect depends) those which will best render the effect desired : this is the course to be followed by the etcher. There is plenty of the instinctive which practice will develop in him, and in this he will find a growing charm and an irresistible attraction. What happy effects, what surprises, what unforeseen discoveries, when the var-

nish is removed from the plate! A bit of good luck and of inspi-
ration often does more than a methodical rule, whether we are
engaged on subjects of our own invention, — *capricci*, as the
Italians call them, — or whether we are drawing from nature di-
rectly on the copper. The great aim is to arrive at the first onset
at the realization of our ideas as they are present in our mind.
An etching must be virginal, like an improvisation.

9. **Expression of Individuality in Etching.** — Having once
mastered the processes, the designer or painter need only carry
his own individuality into a species of work which will no longer
be strange to him, there to find again the expression of the talent
which he displayed in another field of art. He will comprehend
that etching has this essentially vital element, — and in it lies the
strength of its past and the guaranty of its future, — that, more
than any other kind of engraving on metal, it bears the imprint of
the character of the artist. It personifies and represents him so
well, it identifies itself so closely with his idea, that it often seems
on the point of annihilating itself as a process in favor of this idea.
Rembrandt furnishes a striking example of this : by the inter-
mixture and diversity of the methods employed by him, he arrived
at a suavity of expression which may be called magical ; he dif-
fused grace and depth throughout his work. In some of his
plates the processes lend themselves so marvellously to the
severest requirements of modelling, and attain such an extreme
limit of delicacy, that the eye can no longer follow them, thus
leaving the completest enjoyment to the intellect alone.

Claude Lorrain, on the other hand, knew how to conciliate
freedom of execution with majesty of style.

10. **Value of Etching to Artists.** — Speaking of this subordi-
nation of processes in etching to feeling, I am induced to point
out how many of the masters of our time, judging by the char-
acter of their work, might have added to their merits had they
but substituted the etcher's needle for the crayon. Was not De-
camps, who handled the point but little, an etcher in his drawings
and his lithographs ? Ingres only executed one solitary etching,
and yet, simply by virtue of his great knowledge, it seems as if in
it he had given a presentiment of all the secrets of the craft.
And did not Gigoux give us a foretaste of the work of the acid,

when he produced the illustrations to his " Gil Blas," conceived in the spirit of an etcher, which, after thirty years of innumerable similar productions, are still the *chef-d' œuvre* and the model of engraving on wood. And would Mouilleron have been inferior, if from the stone he had passed to the copper plate ? It would be an easy matter to multiply examples chosen from among the artists who have boldly handled the needle, or from among those who might have taken it up with equal advantage, to prove that etching is not, as it has been called, a secondary method. There are no secondary methods for the manifestation of genius.

11. **Versatility of Etching.** — The needle is the crayon ; the acid adds color. The needle is sometimes all the more eloquent because its means of expression are confined within more restricted limits. It is familiar and lively in the sketch, which by a very little must say a great deal ; the sketch is the spontaneous letter. It all but reaches the highest expression when it is called in to translate a grand spectacle, or one of those fugitive effects of light which nature seems to produce but sparingly, so as to leave to art the merit of fixing them.

12. **Etching compared to other Styles of Engraving.** — By its very character of freedom, by the intimate and rapid connection which it establishes between the hand and the thoughts of the artist, etching becomes the frankest and most natural of interpreters. These are the qualities which make it an honor to art, of which it is a glorious branch. All other styles of engraving can never be any thing but a means of reproduction. We must admire the knowledge, the intelligence, and the self-denial which the line-engraver devotes to the service of his art. But, after all, it is merely the art of assimilating an idea which is foreign to him, and of which he is the slave. By him the *chefs-d' œuvre* of the masters are multiplied and disseminated, and sometimes, in giving eternity to an original work, he immortalizes his own name ; but the part he has assumed inevitably excludes him from all creative activity.

13. **Etching as a Reproductive Art.** — These reserves having been made in regard to the engraver, whose instrument is the burin, justice requires that the reproductive etcher should come in for his proportional share, and that his functions should be

defined. Some years ago, a school of etchers arose among
us, whose mission it is to interpret those works of the brush
which, by the delicacy and elegance of their character, cannot be
harmonized with the severity of the burin. This school, to which
Mr. Gaucherel gave a great impulse, has been called in to fill a
regrettable void in the collections of amateurs. Every one knows
those remarkable publications, *Les Artistes Contemporains*, and
Les Peintres Vivants, which, for the last twenty years, have re-
produced in lithography the *chefs-d'œuvre* of our exhibitions of
paintings. To-day etching takes the place of lithography ; it
excels in the reproduction of modern landscapes, and of the
genre subjects which we owe to our most esteemed painters. It
is not less happy in the interpretation of certain of the old masters,
whose works make it impossible to approach them with the burin.
The catalogues of celebrated galleries which have lately been sold
also testify to the important services rendered to art by the repro-
ductive etcher. His methods are free and rapid ; they are not
subjected to a severe convention of form. He may rest his own
work on the genius of others, so as to attain a success like that
of the painter-etcher ; but the latter, as he bathes his inspiration
in the acid and triumphantly withdraws it, finds his power and
his resources within himself alone. He is at once the translator
and the poet.

CHAPTER II.

TOOLS AND MATERIALS. — PREPARING THE PLATE. — DRAWING
ON THE PLATE WITH THE NEEDLE.

14. **Method of Using this Manual.** — As the general theory
given in the preceding chapter may seem too brief, and may con-
vey but an incomplete idea of the different operations involved in
etching, I shall now endeavor to formulate, in as concise a manner
as possible, such practical directions as I have had occasion to give
to a young designer, and to different other persons, in my own
studio. I shall provide successively for all the accidents which
usually, or which may possibly, occur. But the beginner need not
trouble himself too much about the apparent complication of
detail which the following pages present. They are intended,
rather, to be consulted, like a dictionary, as occasion arises. In
all cases, however, it will be well, on reading the book, to make
immediate application of the various directions given, so as to
avoid all confusion of detail in the memory, and to escape the
tedium of what would otherwise be rather dry reading.

A. TOOLS AND MATERIALS.

15. **List of Tools and Materials needed.** — To begin with,
we must provide ourselves with the following requisites : —

Copper plates.
A hand-vice.
Ordinary etching-ground and transparent ground in balls.
Liquid stopping-out varnish.
Brushes of different sizes.
Two dabbers, — one for the ordinary varnish, the other for the white
or transparent varnish.

A wax taper.
A needle-holder.
Needles of various sizes.
A dry point.
A burnisher.
A scraper.
An oil-stone of best quality.
A lens or magnifying-glass.
Bordering-wax.
An etching-trough made of gutta-percha or of porcelain.
India-rubber finger-gloves.
Nitric acid of forty degrees.
Tracing-paper.
Gelatine in sheets.
Chalk or sanguine.
Emery paper, No. oo or ooo.
Blotting-paper.
A roller for revarnishing, with its accessories.

To these things we must add a supply of *old* rags.

16. **Quality and Condition of Tools and Materials.** — Too much care cannot be taken as regards the quality of the copper, which metal is used by preference for etching. Soft copper bites slowly, while on hard copper the acid acts more quickly and bites more deeply. It is to be regretted that nowadays plates are generally rolled, which does not give density enough to the metal. Formerly they were hammered, and the copper was of a better quality. Thus hammered, the metal becomes hard, and is less porous ; its molecular condition is most favorable to the action of the acid, the lines are purer, and even when the work is carried to the extreme of delicacy, it is sure to be preserved in the biting.

English copper plates, and plates that have been replaned, are excellent. It is a good plan to buy thick plates, of a dimension smaller than that of the designs to be made, and to have them hammered out to the required size. The plates thus obtained will not fail to be very good.

The vice must have a wooden handle, so as to prevent burning the fingers.

To meet all possible emergencies, lamp-black may be mixed

with the liquid stopping-out varnish (*petit vernis liquide*). Some engravers find that it dries too quickly, and therefore, fearing that it may chip off under the needle, use it only for stopping out; for retouching, they employ a special retouching varnish (*vernis au pinceau*).

For brushes, select such as are used in water-color painting.

The silk with which the dabbers are covered must be very fine in the thread.

In order to protect his fingers, an engraver conceived the idea of smoking his plates by means of the ends of several candles or wax tapers placed together in the bottom of a little vessel: they furnish an abundance of smoke, and can be extinguished by covering up the vessel. The smoke of a wax taper is the best; it is excellent for small plates.

The needle-holder holds short points of various thicknesses, down to the fineness of sewing-needles.

To sharpen an etching-needle, pass it over the oil-stone, holding it down flat, and turning it continually. When it has attained a high degree of sharpness, describe a large circle with it on a piece of cardboard, holding it fixed between the fingers this time, and go on describing circles of a continually decreasing size. The nearer you approach to the centre, the more vertical must be the position of the needle. The fineness or the coarseness of the point is regulated by keeping the needle away from, or bringing it nearer to, the central point.

The dry point must be ground with flat faces rather than round, so as to cut the copper, and penetrate it with ease.

If the burnisher is not sufficiently polished, it scratches the copper, and produces black spots in the proofs. To keep it in good condition, cut two grooves, the size of the burnisher, in a piece of pine board. Rub it up and down the first of these grooves, containing emery powder; and then, to give it its final lustre, repeat the same process, with tripoli and oil, in the second groove.

The stones which are too hard for razors are excellent for the scrapers. Having sharpened the scraper with a little oil, during which operation you must hold it down flat on the stone, pass it over your finger-nail. If the touch discloses the presence of the

least bit of tooth, and if the tool does not glide along with the greatest ease, the grinding must be continued, as otherwise the scraper will scratch the copper.

You are at liberty to use two troughs, — one for the acid bath ; the other, filled with water, for washing the plate.

A glass funnel, and a bottle with a ground-glass stopper, will be necessary for filling in and keeping the etching liquid.

Various substances are used for finishing off the copper plates ; the most natural is the paste obtained by rubbing charcoal on the oil-stone with oil.

Then comes the fine emery paper Nos. oo or ooo, rotten-stone, tripoli, English red, and, finally, slate. Powdered slate, produced by simply scraping with a knife, is excellent, used with oil and a fine rag, the same as other substances.

The varnish for revarnishing is nothing but ordinary etching-ground, dissolved in oil of lavender. It must be about as stiff as honey in winter.

The rollers for revarnishing, which can be had of different sizes, are cylindrical in form, and are terminated by two handles, which revolve in the hands. The roller ought, if possible, to cover the whole surface of the copper. As soon as it has been used, it must be put out of the way of the dust.

These various recommendations are by no means unnecessary, as the least material obstacle may sometimes hinder the flight of the imagination. It is well to be armed against all the troublesome vexations of the handicraft ; for the difficulties of the art are in themselves sufficient to occupy our attention.

B. Preparing the Plate.

I shall now proceed to give the various talks which I had with my young pupil.

17. **Laying the Ground, or Varnishing.** — You have here a plate, I say to him ; I clean it with turpentine ; then, having well wiped it with a piece of fine linen, and having still further cleaned it by rubbing it with Spanish white (or whiting), I fasten it into the vice by one of its edges, taking care to place a tolerably thick piece of paper under the teeth of the vice, so as to protect the

copper against injury. I now hold the plate with its back over this chafing-dish; but a piece of burning paper, or the flame of a spirit-lamp, will do equally well. As soon as the plate is sufficiently heated, I place upon its polished surface this ball of ordinary etching-ground, wrapped up in a piece of plain taffeta; the heat causes the ground to melt. If the plate is too hot, the varnish commences to boil while melting; in that case, we must allow the plate to cool somewhat, as otherwise the ground will be burned. I pass the ball over the whole surface of the copper, taking care not to overcharge the plate with the ground. Then, with the dabber, I dab it in all directions; at first, vigorously and quickly, so as to spread and equalize the layer of varnish; and finally, as the varnish cools, I apply the dabber more delicately. The appearance of inequalities, and of little protruding points in the ground, indicates that it is laid on too thick, and the dabbing must be continued, until we have obtained a perfectly homogeneous layer. This must be very thin, — sufficient to resist strong biting, and yet allowing the point to draw the very finest lines, which it will be difficult to do with too much varnish.

18. **Smoking.** — Without waiting for the plate to cool, I turn it over, and present its varnished side to the smoke of a torch or a wax taper, which I hold at a distance of about two centimetres from the plate, so as not to injure the varnish. I keep moving the flame about in all directions, to avoid burning the varnish (which latter would take place if the flame remained too long at the same point), and thus I obtain a brilliant black surface. All the transparency is gone; we see neither copper nor varnish, and this is a sign that our operation has succeeded. All we need do now is to allow the plate to cool and the varnish to harden, and then you can commence making your drawing.

You call my attention to the fact that the varnish, in cooling, loses the brilliancy which it had in its liquid state. This is always the case. And see the perfect neatness and evenness of the varnished and smoked surface! Here is a plate which was spoiled in the smoking. The first thing that strikes us is that we see the marks left by the passage of the taper. At a pinch, these marks might, perhaps, be no inconvenience to us in working; but here the brilliant black is broken by very dull spots. These are

places in which the varnish was burned; it will scale off under the needle, and has lost the power of resisting the acid. We must therefore clean this plate with spirits of turpentine, and commence operations afresh.

The ground is blackened, because its natural transparency does not permit us to see the work of the point. This work produces what might be called a negative design ; that is to say, a design in bright lines on a black ground. This is rather perplexing at first, but you will soon become accustomed to it.

C. Drawing on the Plate with the Needle.

19. **The Transparent Screen.** — You must place yourself so as to face this window, and between you and it we must introduce, in an inclined position, a transparent screen made of tracing paper stretched on a wooden frame, which will prevent your seeing the window. This screen will soften and strain the light ; it will reduce the reflection of the copper, and will allow you to see what you are doing.

In designing on the plate out of doors, the screen is unnecessary, since, as the light falls equally upon the copper from all directions, the reflection is done away with, and the copper does not dazzle the eye as it does when the light emanates from a single source.

20. **Needles or Points.** — You may use a single needle, or you may use several of different degrees of sharpness, even down to sewing-needles, as you will see later on ; but your work on the plate will always look uniform, without distance and without relief. The modelling and coloring of the design must be left to the acid.

The point must be held on the plate as perpendicularly as possible, as the purity of the line depends on the angle of incidence which the point makes with the copper ; furthermore, it must be possible to direct it freely and easily in all directions, and it is, therefore, necessary that the needle should not be too sharp. To make sure of this, draw a number of eights on the margin of your plate, or simply an oblique line from below upwards in the direction of the needle. If it does not glide along easily, if it attacks the copper and catches in it, you must regrind it.

This is important, as in principle the function of the needle is to trace the design by removing the varnish from the copper, while it must avoid scratching it. By scratching the metal we encroach on the domain of the acid, and inequality of work is the result, since the acid acts more vigorously on those parts which have been scratched than on those which have simply been laid bare. We must feel the copper under the point, without, however, penetrating into it.

The opposite effect is produced if we operate too timidly. In this case we do not reach the copper. We remove the blackened surface, and it seems as if we had also removed the varnish, since we see the copper shining through it. But we shall find later, from the fact that the acid does not bite, that we did not bear heavily enough on the needle.

At first there is a tendency to proceed as in drawing on paper, giving greater lightness to the touch of the point in the distances, and bearing on it more vigorously in the foregrounds. But this is useless.

There are certain artists, nevertheless, who prefer to attack the copper with cutting points in the finer as well as in the more vigorous parts of their work, and to bite in with strong acid ; others, again, dig resolutely into the copper wherever they desire to produce a powerful tone. Abraham Bosse, in applying etching to line-engraving, advises his readers to cut the copper slightly in the lines which are to appear fine, and to dig vigorously into the plate for those lines which are to be very heavy, so that delicate as well as strong work may be obtained at one and the same biting. As it is necessary in this sort of engraving to retouch the heavy lines with the burin, we can understand that in the way shown the work of the instrument named may be facilitated.

21. **Temperature of the Room.** — In summer the temperature softens the varnish, and the needle works pliantly and easily ; in winter the cold hardens the varnish, so that it is apt to scale off under the point, especially at the crossing of the lines. It is advisable, therefore, to have your room well heated, or to supply yourself with two cast-metal plates or two lithographic stones, or even two bricks, if you please, which must be warmed and placed under your plate alternately, so as to keep it at a soft and uniform

temperature. Practice has shown that work done at the right temperature is softer than that executed when the varnish is too cold, even if it is not sufficiently so to scale off.

22. **The Tracing.** — According to the kind of work to be done, we shall either draw directly on the plate, or, in the case of a drawing which is to be copied of its own size, we shall make use of a tracing. Many engravers emancipate themselves from the tracing, and accustom themselves to reversing the original while they copy it. The manner of using a tracing is well known. We shall need tracing-paper, paper rubbed with sanguine on one side, and a pencil. The tracing is made on the tracing-paper, and this is afterwards placed on the prepared plate ; between the tracing and the plate we introduce the paper rubbed with sanguine; then, with a very fine lead-pencil, or with a somewhat blunt needle, we go carefully over the lines of the design, which, under the gentle pressure of the tool, is thus transferred in red to the black ground. It is unnecessary to use much pressure, as otherwise your tracing will be obscured by the sanguine and you will find neither precision nor delicacy in it. Furthermore, you run the risk of injuring the ground. The tracing is used simply to indicate the places where the lines are to be, and it must be left to the needle to define them.

23. **Reversing the Design.** — Whenever your task is the interpretation of an object of fixed aspect, such as a monument, or some well-known scene, or human beings in a given attitude, you will be obliged to reverse the drawing on your plate, as otherwise it will appear reversed in the proof. You must, therefore, reverse your tracing, which is a very easy matter, as the design is equally visible on both sides of the tracing-paper. Gelatine in sheets, however, offers still greater advantages when a design is to be reversed. Place the gelatine on the design, and, as it is easily scratched, make your tracing with a very fine-pointed and sharp needle, occasionally slipping a piece of black paper underneath the gelatine to assure yourself that you have omitted nothing. The point, in scratching the gelatine, raises a bur, and this must be removed gently with a paper stump, or with the scraper, after which operation the tracing is rubbed in with powdered sanguine. Having now thoroughly cleaned the sheet,

so that no powder is left anywhere but in the furrows, we turn the sheet over and lay it down on the plate, and finally rub it on its back in all directions, for which purpose we use the burnisher dipped in oil. The design, reversed, will be found traced on the varnish in extremely fine lines.

24. **Use of the Mirror.** — The tracing finished, place a mirror before your plate on the table, and as close by as possible ; between the plate and the mirror fix the design to be reproduced, and then draw the reflected image. For the sake of greater convenience, take your position at right angles to the window instead of facing it, so that the light passing through the transparent screen on your left falls on the mirror and the design, as well as on your work. When drawing on the copper from nature, if the design is to be reversed, you must place yourself with your back to the object to be drawn, and so that you can easily see it in a small mirror set up before your plate. This is the way Méryon proceeded : standing, and holding in the same hand his plate and a little mirror, which he always carried in his pocket, he guided his point with the most absolute surety, without any further support.

25. **Precautions to be observed while Drawing.** — Before you begin to draw you must trace the margin of your design, for the guidance of the printer. To protect your plate, it will be necessary to cover it with very soft paper ; the pressure of the hand does no harm, provided you avoid rubbing the varnish. If you should happen to damage it, you must close up the brilliant little dots which you will observe, by touching them up, very lightly and with a very fine brush, with stopping-out varnish.

26. **Directions for Drawing with the Needle.** — I might now let you copy some very simple etching ; but your knowledge of drawing will, I believe, enable you to try your hand at a somewhat more important exercise. Let us suppose, then, that you are to draw a landscape, although the practice you are about to acquire applies to all other subjects equally well. Will you reproduce this design by Claude Lorrain ? (Pl. II.) It is a composition full of charm and color, and very harmonious in effect. Use only one needle, and keep your work close together in the distance and more open in the foreground. (See Pl. I *a*.) That appears paradoxical to you ; but the nitric acid will soon tell you why this is so. I shall indicate to you, after your plate has been

bitten, those cases in which you will have to proceed differently, or, in other words, in which you will have to draw your lines nearer together or farther apart without regard to the different distances. I cannot explain this subject more fully before you have become acquainted with the process of biting in, as without this knowledge it must remain unintelligible to you. This remark holds good, also, of what I have told you on the subject of the needles of different degrees of sharpness.

"It is curious, my dear sir, to notice how at one and the same time the point combines a certain degree of softness and of precision ; those who draw with the pen ought also to be admirers of etching. It seems to me, however, that my lines are too thick ; I have already laid several of them, and the varnish is no longer visible ; I am afraid I have taken it up altogether."

You need not feel any uneasiness about that ; it is simply owing to the irradiation of the copper, the brilliancy of which the screen does not completely subdue. The bright line is made to look broader than it really is by the brilliant gloss of the metal. But if you lay a piece of tracing-paper on the plate you will see the lines as they really are ; that is to say, with plenty of space between them. By the aid of a lens you can convince yourself still more easily ; you will often have occasion to avail yourself of this instrument to enable you to do fine work with greater facility, or to give you a better insight into what you have already done.

As the irradiation of which we have just spoken is apt to deceive us in regard to the quantity of the work done, we may happen to find less of it than we expected when the plate has been bitten. Plates which to the beginner seem to be quite elaborately worked, present to the acid lines widely spaced and insufficient in number, thus necessitating retouches. It is essential, therefore, in principle (except in the special cases to be pointed out hereafter), to give to our work, in its first stages, all the development that is necessary.

I forgot to tell you that you must provide yourself with a very soft brush, say a badger, which, from time to time, you must pass lightly over your plate so as to remove the small particles of varnish raised by the needle. Otherwise you will not be able to see properly what you have been doing.

Continue, and follow your own feeling ; work away without fear of going wrong ; some of your errors you will be able to remedy. Thus, if you have made a mistake, you can lay a thin coat of liquid varnish over the spoiled part by means of a brush ; in a few seconds the varnish will have dried, and you can make your correction. You can employ this method for the correction of a faulty line, or to restore a place which should have remained white, but which you have inadvertently shaded.

Here I shall stop for the present, and shall close by saying, May good luck attend your point, as well as your acid ! There is nothing more to be said to you until after your plate has been bitten.

CHAPTER III.

27. **Bordering the Plate.** — This work took some time. Our young student, impatient to see the transformation wrought by the acid, came back without keeping me waiting for him.

"Hurry up! A tray, acid, and all the accessories!"

Instead of using a tray, I tell him, we can avail ourselves of another method, which is used by many engravers, and which consists in bordering the plate with wax. This wax, having been softened in warm water, is flattened out into long strips, and is fastened hermetically and vertically around the edges of the plate, so that, when hardened, it forms the walls of a vessel, the bottom of which is represented by the design drawn with the point. To avoid dangerous leaks, heat a key, and pass it along the wax where it adheres to the plate; the wax melts, and, on rehardening, offers all possible guarantees of solidity. We now pour the acid on the plate thus converted into a tray, and as we have taken care to form a lip in one of the angles made by the bordering wax, it is an easy matter to pour off the liquid after each biting. This proceeding is useful in the case of plates which are too large for the tray. Otherwise, however, I prefer a tray made of gutta-percha or porcelain.

28. **The Tray.** — Let us now install ourselves at this table, and let us cover the margin and the back of the plate with a thick coat of stopping-out varnish. As soon as the varnish is perfectly dry, we place the plate into the tray standing horizontally on the table, and pour on acid enough to cover it to the height of about a centimetre. This depth, which is sufficient for biting, allows the eye to follow the process in its various stages.

29. **Strength of the Acid.** — This acid is fresh, and has not yet been used ; bought at forty degrees, I mix it with an equal quan-

tity of water, which reduces it to twenty degrees. This is the strength generally adopted for ordinary biting. Its color is clear, and slightly yellow ; but as soon as it takes up the copper it becomes blue, and then green. As, in its present state, it would act too impetuously, I add to it a small quantity of acid which has been used before. You may also throw a few scraps of copper into it the day before using it; the old etchers used for this purpose a copper coin, larger or smaller, according to the volume of the bath.

30. **Label your Bottles !** — One day, one of my pupils, having a bad cold, did not notice the difference between the smell of the acid and that of the turpentine, and so plunged a plate which he desired to bite, into a bath of the latter fluid. "It's queer," he said, "this won't bite, and yet the varnish scales off. . . . The lines keep enlarging, and run into one another ! What does this curious medley mean, which appears on the plate ?" It was simple enough. The spirits of turpentine had dissolved the ground, and consequently the plate developed a shining and radiating surface before the eyes of our wondering student, as if it had just left the hands of the plate-maker.

Advice to those who are absent-minded, and who are liable to mistake fluids which look alike for one another, — Label your bottles !

31. **The First Biting.** — Let us make haste now, I say to my pupil, to do our biting. As the heat of the day abates, the acid becomes less active ; and besides, to judge by the delicate character of the original we are to render, we shall need at least two or three hours, all told, for this operation. The task before us consists in the reproduction of a given work, the merit of which lies in the gradation in the various distances. It needs time and attention to be able to carry all the necessary processes successfully into practice.

It will be plain to you, from what I have just said, that the operation you are about to engage in is one of the most delicate in the etcher's practice. There is the plate in the acid ; the liquid has taken hold of the copper ; but your sky must be light, and a prolonged corrosion would therefore be hurtful to it. Hence we take the plate out of the bath, pass it through pure water, so that

no acid is left in the lines, and cover it with several sheets of blotting-paper, which, being pressed against it by the hand, dries the plate. We shall have to go through the same process after each partial biting, because if the plate were moist, the stopping-out varnish which we are going to apply to it would not adhere.

32. **The Use of the Feather.**—You noticed the lively ebullitions on the plate, which took place twice in succession. After the first, I passed this feather lightly over the copper, to show you its use. Its vane removed the bubbles which adhered to the lines. This precaution is necessary, especially when the ebullitions acquire some intensity and are prolonged, to facilitate the biting, as the gas by which the bubbles are formed keeps the acid out of the lines. If these bubbles are not destroyed, the absence of biting in the lines is shown in the proofs by a series of little white points. Such points are noticeable in some of the plates etched by Perelle, who, it seems, ignored this precaution.

33. **Stopping Out.** — The two rapid ebullitions which you saw may serve you as a standard of measurement ; the biting produced by them must be very light, and sufficient for the tone of the sky. You may, therefore, cover the entire sky with stopping-out varnish by means of a brush, taking care to stop short just this side of the outlines of the other distances. The importance of mixing lamp-black with your stopping-out varnish to thicken it, comes in just here ; because if it remained in its liquid state, it might be drawn by capillary attraction into the lines of those parts which you desire to reserve, and thus, by obstructing them, might stop the biting in places where it ought to continue. Wait till the varnish has become perfectly dry ; you can assure yourself of this by breathing upon it ; if it remains brilliant, it is still soft, and the acid will eat into it ; but as soon as it is dry it will assume a dull surface under your breath.

34. **Effect of Temperature on Biting.** — Let us now return the plate to the bath, to obtain the values of the other distances. The temperature has a great effect on the intensity of the ebullitions, and it is hardly possible to depend on it absolutely as a fixed basis on which to rest a calculation of the time necessary for each biting, as its own variability renders it difficult to appreciate the aid to be received from it. In winter, for instance, with

the same strength of acid, it needs four or five times as much time to reach the same result as in summer, so that on very hot days the biting progresses so rapidly that the plate cannot be lost sight of for a single moment without risk of over-biting.

35. **Biting continued.** — We have now obtained several moderate ebullitions, and as it would not do to exaggerate the tone of the mountain in the background, it is time to withdraw the plate once more. Uncover a single line by removing the ground, either with the nail of your finger or with a very small brush dipped into spirits of turpentine, to examine whether it is deeply enough bitten for the distance which it is to represent. If the depth is not sufficient, cover it with stopping-out varnish, and bite again. This is not necessary, however, in our present case, and you may therefore stop out the whole background. Remember, if you please, that the line must look *less* heavy than it is to show in the proof; for you must take into account the black color of the printing-ink. With your brush go over the edges of the trees which are to be relieved rather lightly against the sky, as well as over that part of the shadow in this tower which blends with the light. There are also some delicate passages in the figure of the woman in the foreground, in the details of the plants, and in the folds of this tent (Pl. Ia). Stop out all these, and do not lose sight of the values of the original (Pl. II.). Make use of the brush to revarnish several places which are scaling off on the margin and the back of the plate. The temperature is favorable; the ebullitions come on without letting us wait long, and the plate is bluing rapidly. I do not like to see these operations drag on; in winter, therefore, I do my biting near the fire. We soon acquire a passion for biting, and take an ever-growing interest in it, which is incessantly sharpened by thinking of the result to which we aspire. Hence the desire of constant observation, and that assiduity in following all the phases of the biting-in.

I notice that the acid does not act on certain parts of your work; you will find out soon enough what that means.

36. **Treatment of the Various Distances.** — " I am thinking just now of what you told me in regard to the background : — that more work ought to be put into it than into the foreground."

Nothing, indeed, is simpler. You understand that the background, which is bitten in quite lightly, must show very delicate lines, while in the middle distance and in the foreground the lines are enlarged by the action of successive bitings. When it comes to the printing, the quantity of ink received by these various lines will be in proportion to the values which you desired to obtain, and in the proofs you will have a variety of lighter or stronger tones, giving you the needed gradations in the various distances. It follows from this that, if you had worked too sparingly on the distances which receive only a light biting, you could not have reached the value of the tone which you strove to get, and if you had worked too closely on those parts which require continued biting, you would have had a black and indistinct tone, because the lines, which are enlarged by the acid, and consequently keep approaching one another, would finally have run together into one confused mass, producing what in French is called a *crevé* (blotch).

In an etching the space between the lines must be made to serve a purpose ; for the paper seen between the black strokes gives delicacy, lightness, and transparency of tone.

37. **The Crevé.** — **Its Advantages and Disadvantages.** — In very skilled hands the *crevé* is a means of effect. If you wish to obtain great depth in a group of trees, in a wall, in very deep shadows, you will risk nothing by intermingling your lines picturesquely and biting them vigorously. In this way you can produce tones of velvety softness, and at the same time of extraordinary vigor. Similarly, you may strike a fine note by means of running together several lines which, if sufficiently bitten, will form but a single broad one of great solidity and power. It is, indeed, only the exaggeration of this expedient, which, by unduly enlarging the limits of the broad line just spoken of, and thus producing a large and deep surface between them, constitutes the *crevé* properly so called ; the printing ink has no hold in this flat hollow, and a gray spot in the proof is the result. I have warned you of the accident ; later on you shall hear something of the remedy. We will now continue our biting. Plunge your plate into the bath again, if you please.

38. **Means of ascertaining the Depth of the Lines.** — " My dear sir, I see that my drawing turns black ; it disappears almost

entirely, and is lost in the color of the ground. I am quite per-
plexed. My mind endeavors to penetrate beneath this varnish,
so as to be able to witness the mysterious birth of my *œuvre*.
See these violent ebullitions ! What do you think of them ? "

Let them go on a moment longer, and then withdraw your
plate. We have now arrived at a point where the eye cannot
judge of the work of the acid as easily as before ; henceforth we
must, therefore, examine the depth of our bitings by uncovering
a single line, as, for instance, this one here in the ground. Or
we may even lay bare, by the aid of spirits of turpentine, a part of
the foreground, provided, however, that we must not forget to
cover it again with the brush. This will give us an idea of the
total effect so far produced by the biting, and we can then regu-
late the partial bitings which are still to follow, either by a com-
parison of the time employed on those that have gone before, or
by the intensity of the ebullitions, the action of which on the
copper we have already studied. You perceive that, while it is
difficult to fix a standard of time for the bitings at the beginning
of the operation, it is yet possible to calculate those to come by
what we have so far done.

39. **The Rules which govern the Biting are subordinated
to various Causes.** — In reality, it is impossible to establish
fixed rules for the biting, for the following reasons : —

1. Owing to the varying intensity of the stroke of the needle.
The etcher who confines himself to gently baring his copper must
bite longer than he who attacks his plate more vigorously, and
therefore exposes it more to the action of the acid.

2. Owing to the different quality of the plates.

3. Owing to the difference in temperature of the surrounding
air : — of this we have before spoken.

4. Owing to difference of strength in the acid, as it is impossi-
ble always to have it of absolutely the same number of degrees.
At 15° to 18° the biting is gentle and slow ; at 20° it is moder-
ate ; at 22° to 24° it becomes more rapid. It would be dangerous
to employ a still higher degree for the complete biting-in of a
plate, especially in the lighter parts.

40. **Strong Acid and Weak Acid.** — It is, nevertheless, possi-
ble to put such strong acid to good service. A fine gray tint

may, for instance, be imparted to a well-worked sky by passing a broad brush over it, charged with acid at 40°. But the operation must be performed with lightning speed, and the plate must instantly be plunged into pure water.

As a corollary of the fourth cause, it is well to know that an acid overcharged with copper loses much of its force, although it remains at the same degree. Thus an acid taken at 20°, but heavily charged with copper from having been used, will be found to be materially enfeebled, and to bite more slowly than fresh acid at 15° to 18°. To continue to use it in this condition would be dangerous, because there is no longer any affinity between the liquid and the copper, and if, under such circumstances, you were to trust to the appearance of biting (which would be interminable, besides), you would find, on removing the varnish, that the plate had merely lost its polish where the lines ought to be, without having been bitten. It is best, therefore, always to do your biting with fresh acid, constantly renewed, as the results will be more equal, and you will become habituated to certain fixed conditions.

Some engravers, of impetuous spirit and impatient of results, do their biting with acid of a high degree, while others, more prudent, prefer slow biting, which eats into the copper uniformly and regularly, and hence they employ a lower degree. In this way the varnish remains intact, and there is not that risk of losing the purity of line which always attends the employment of a stronger acid.

41. **Strength of Acid in relation to certain Kinds of Work.** — Experience has also shown that, with the same proportion in the time employed, the values are accentuated more quickly and more completely by a strong than by a mild acid ; this manifests itself at the confluence of the lines, where the acid would play mischief if the limit of time were overstepped.

Another effect of biting which follows from the preceding, is noticeable in lines drawn far apart. Of isolated lines the acid takes hold very slowly, and they may therefore be executed with a cutting point and bitten in with tolerably strong acid.

The reverse takes place when the lines are drawn very closely together ; the biting is very lively. Work of this kind, therefore, demands a needle of moderate sharpness and a mild acid.

Hence, interweaving lines and very close lines are bitten more deeply by the same acid than lines drawn parallel to each other, and widely spaced, although they may all have been executed with the same needle. If, in an architectural subject, you have drawn the lines with the same instrument, but far apart on one side, and closely and crossing each other on the other, you must not let them all bite the same length of time, if you wish them to hold the same distance. It will be necessary to stop out the latter before the former, otherwise you will have a discordant difference in tone. There will be inequality in the biting, but it will not be perceptible to the eye, as the general harmony has been preserved. (See Pl. IV. Fig. 1.)

In short, strong acid rather widens than deepens the lines; mild acid, on the contrary, eats into the depth of the copper, and produces lines which are shown in relief on the paper, and are astonishingly powerful in color. This is especially noticeable in the etchings of Piranesi, who used hard varnish.

42. **Last Stages of Biting.** — But let us return to our operation. You noticed that I allowed your plate to bite quite a while; this was necessary to detach your foreground and middle-ground vigorously from the sky and the background. You may now stop out the trees, the tower, and the tent in the middle-ground, and the vertical part of the bridge, which is in half-tint, and then proceed. Note that the number of bitings is not fixed, but depends on the effect to be reached.

"In that case it is to be hoped, for the sake of my apprentice hands, that I shall never have many bitings to do. Just look at my fingers! They are in a nice state. The prettiest yellow skin you ever saw!"

Oh, don't let that color trouble you; it will be all black by to-morrow.

"Much obliged to you for this bit of consolation!"

Besides, it will take you a week to grow a new skin. In future you must soak your fingers in pure water whenever you have got them into the acid. You might have used india-rubber finger-gloves; they are excellent to keep the hands clean, but it is not worth while to trouble about them for the present, as we are almost done. I think you may now stop out all that remains, with

the exception of the darkest places in the foreground, to which we must give a final biting.

There! Now we've got it! Withdraw your plate for the last time, and as there are some very widely spaced lines in this tree in the foreground, you will risk nothing by giving them a final touch with pure acid. The strongest accent in the landscape rests on this spot; it determines the color of the whole. By this application of pure acid we shall get a vigorous tone, a powerful effect.

I may as well tell you here that it is sometimes advisable to add a small quantity of pure acid to the bath towards the end of the operation, so as to increase the activity of the biting on certain parts of the plate without running into excess. But as the place now under consideration is restricted, we shall adopt another means, so as to limit the action of the acid to the given point. See here: I let fall a few drops; the pure acid eats into the copper with great vehemence; the metal turns green, and the ebullition subsides. Now take up the exhausted liquid with a piece of blotting-paper, and let us commence again. Under these newly added drops of fresh acid, the varnish is ready to scale off, the lines sputter, and assume a strange yellow color; these golden vapors announce that the operation is finished.

What follows, is the task of the printer; his press will tell us whether we have won, or whether we have been mated. Clean the plate with spirits of turpentine, using your fingers, or with a very clean old rag (calico, if possible), if you are afraid to soil your hands. Be sure to have the plate well cleaned, but take care not to scratch it.

The acid, which may be of use hereafter, we will turn into a glass bottle with a ground stopper, and will store it in some safe place.

CHAPTER IV.

FINISHING THE PLATE.

43. Omissions. — Insufficiency of the Work so far done. — The result you have obtained, I tell my pupil, as he shows a proof of the *first state* of his plate to me, is not final. Your work needs a few retouches and slight modifications, not counting the little irregularities which I had foreseen, and which it will be easy enough to repair. We will proceed in order. (See Pl. I^a). To commence with, here are certain parts which are sufficiently bitten, and which, nevertheless, are indecisive in tone, and do not hold their place. I allude to the columns and to the trees in the further distance ; one feels that there is something wanting there, which must be added. You must, therefore, re-cover your plate, in the manner already known to you, either with transparent ground, or with ordinary etching-ground, just as if the plate had never yet been touched by the needle.

44. Transparent Ground for Retouching. — The white or transparent ground or varnish admirably allows all previous work to show through. It is preferred to the ordinary ground for working over parts that have been insufficiently bitten, on account of its transparency, which leaves even the finest lines visible, while under the ordinary ground these lines might be lost entirely. It will be an easy matter for you to combine the new work with the old ; the very slight shadow thrown on the copper by the transparent ground will give a blackish appearance to your lines, which may serve as a guide to you, and, with your proof before your eyes, you will readily succeed in finding the places which need retouching. To make assurance doubly sure, you can indicate the retouches on your proof with a lead-pencil.

The transparent ground has occasionally been found to crack and scale off, when left in the bath for a long while, or when

strong acid is used. But as you are only going to use it for light and, consequently, short biting, you need not fear this danger. Another inconvenience, which may easily be prevented, consists in the presence of small bubbles of air, which appear on the varnish as soon as it begins to melt. Heat the plate just to the proper point of melting, and dab it vigorously for some length of time, until the varnish cools; then hold the back of the plate flat to the fire; the varnish melts again, and the rest of the bubbles disappear. If some of them should prove to be obstinate, cover them very lightly with the brush, as otherwise the acid will penetrate through the passages thus left open, and will make little holes in the copper, which, on removing the varnish, will cause an unpleasant surprise. You shall hear more of this further on.

45. **Ordinary Ground used for Retouching. — Biting the Retouches.** — Ordinary etching-ground, such as we used in the first instance, does not show the work previously done as well as the transparent ground, but the later additions are seen all the better on it. It may be used in its natural state, or it may be smoked. It is preferable to the transparent varnish, whenever the work already achieved is deeply bitten, and hence easily seen.

In the present case my advice is that you use the ordinary ground. Having made your retouches, introduce your plate into the bath, and proceed as before, by partial biting, endeavoring, as much as possible, to obtain the same intensity of tone. These additions, thus bitten by themselves, will mingle with the lines previously drawn, and now protected by the varnish.

It is hardly possible to judge of the additions, especially on transparent varnish, until they have been bitten in. But, if you should then find that you have not yet reached your point, you can revarnish the plate once more, and complete the parts that appear to be unfinished.

I must also call your attention to the fact, that all lines drawn on transparent ground seem to thicken most singularly, as soon as the acid begins to work. But do not let that deceive you.

Now look at this spot in the immediate foreground (Pl. Ia), which has a somewhat coarse appearance. It is much softer in the original (represented by Pl. II.). You must add a few lines, and must bite them rather lightly; they will mingle agreeably

with the energetic lines of the first state. You may put the large trees through the same process, and you will find that they gain in lightness by it. Later on, when you have acquired more experience, you will occasionally find it handy to make these additions between two bitings. You will thus reach the desired result without the necessity of regrounding your plate.

Sometimes, when using strong acid for these retouches, the lines first drawn are also attacked by the liquid. In that case, stop the biting immediately, and rest contented with what you have got. It is not difficult to understand why these revarnished lines should commence to bite again, more especially if they are deep : the acid, finding the edges of the lines (which are sharp and angular, and therefore do not offer much hold to the varnish) but indifferently protected, attacks them, without going into their depths. The ravages thus committed along the edges of the lines may be quite disastrous ; and it is well, therefore, whenever you revarnish a plate, to give additional protection to those parts which are not to be retouched, by going over them with stopping-out varnish.

46. **Revarnishing with the Brush.** — Instead of revarnishing with the dabber, the ground may also be laid with the brush. For this purpose you can use the stopping-out varnish mixed with lamp-black. Spread a coat of varnish all over the plate, using a very soft brush ; if the copper should not be perfectly covered on the edges of the deeply etched lines, add a second coat of varnish. Do not wait till the varnish has become too dry before you execute the retouches, which, of course, must also be bitten in as usual. Mixed with lamp-black, the stopping-out varnish allows even the finest lines to be seen, which would not show as well if the varnish were used in its natural state. Many engravers use this varnish instead of the transparent ground.

47. **Partial Retouches. — Patching.** — For partial retouches and for patching the stopping-out varnish is also used, but in a simpler and more expeditious way. Cover the part in question with a tolerably thick coat of varnish, and when you have finished your retouch, slightly moisten the lines with saliva, to prevent the few drops of acid which you supply from your bath with the brush from running beyond the spot on which they are to act. If pure

acid is used, — which is still more expeditious, — the effervescence
is stopped by dabbing with a piece of blotting-paper, and the
operation is repeated as long as the biting does not appear to be
sufficient. For very delicate corrections it is advisable not to
wait until the first ebullition is over ; but it must be left to the
feeling to indicate the most opportune moment for the application
of the blotting-paper. If you proceed rapidly and cautiously, you
can obtain extremely fine lines in this way, as you have had occa-
sion to see under other circumstances (see paragraph 40, p. 25).

You may recollect that I spoke of lines which had not bitten :
I alluded to this spot in the middle of the bridge (see Pl. Ia).
You did not bear on your needle sufficiently, and hence it did not
penetrate clear down to the copper; consequently, after having
compared the proof of the first state with the original (Pl. II.),
you must do the necessary patching according to the instructions
just given to you.

48. **Dry Point.** — Whenever it is necessary to retouch, or to
add to very delicate parts of the plate, such as the extreme dis-
tance, or any other part very lightly bitten, it is safer to use the
dry point, as in such cases retouching by acid is a most difficult
thing to do. The tone must be hit exactly, and without exag-
geration.

Your plate offers an opportunity for the use of the dry point :
the sky and the mountain are partly etched ; you can improve
them by a few touches of the dry point.

The dry point is held in a perpendicular position, and is used
on the bare copper. It must be ground with a cutting edge, and
very sharp, so that it may freely penetrate into the copper, and
not merely scratch it. You cut the line yourself, regulating its
depth by the amount of pressure used, and according to the tone
of the particular passage on which you are working. For patch-
ing, it is more frequently used in delicate passages than in others,
as, even with great pressure, the strength of a dry point line will
always be below that of a line deeply bitten. In printing, the
dry point line has less depth of color than the bitten line, as the
acid bites into the copper perpendicularly at right angles ; while
the furrow produced by the dry point, which offers only acute
angles, takes up less ink, although it appears equally broad. This

inequality disappears if a plate in which etched lines and dry point work are intermingled is re-bitten ; the difference in tone is then equalized.

On the other hand, the difference in the appearance of etched lines and dry point work produces curious effects. Thus, if a passage which is too strong and appears to stand out is to be corrected, a few touches of the dry point will be sufficient to soften it, and to push it back to another distance.

The dry point is not only used for retouching ; it is sometimes employed, without any etching, to put in the whole background.

49. **Use of the Scraper for removing the Bur thrown up by the Dry Point.**— The dry point work being finished, the *bur* thrown up by the instrument must be removed. The bur is the ridge raised on the edge of the line, as the point ploughs through the metal ; you can satisfy yourself of its existence by the touch. In printing, the ink catches in this ridge, and produces blots. The bur is removed by means of the *scraper*, an instrument with a triangular blade, one of the sides of which, held flat, is passed over the plate in the opposite direction to that of the stroke of the point, and so as to take the line obliquely. You need not feel any anxiety about injuring the plate ; the touch will tell you when the bur has disappeared. In the case of dry point lines crossing one another, each set running in a different direction must be drawn as well as scraped separately, in the manner just described ; otherwise you will run the risk of closing the lines which cross the path of the scraper, by turning the bur down into the furrows.

50. **Reducing Over-bitten Passages.** — So much for the additions. We will now pass on to the very opposite : the shadow thrown by the parapet, and the ground between the man and the woman, have been *over-bitten*. These parts do not harmonize with the neighboring parts, and are stronger in tone than the corresponding parts of the original.

To remedy this, there are four means at your command : —

The Burnisher.	The Scraper.
Charcoal.	Hammering out.

51. **The Burnisher.**—As these passages are limited in extent, and not very deeply bitten, you may use the burnisher to reduce

them. Moisten it with saliva, and take only a small spot at a
time, holding the instrument down flat. If you were to use only
the end, you might make a cavity in the copper. The burnisher
flattens and enlarges the surface of the copper, and consequently
diminishes the width of the line. The tone, therefore, is reduced.

On fine, close, and equal work the burnisher does excellent
service, the effect being analogous to that of the crumb of bread
on a design on paper.

It is less efficacious on deeply bitten work, because it rounds
off the edges of the lines as it penetrates into the furrows, and
thus detracts somewhat from the freshness of tone, — an unpleas-
ant result, which, in very fine work, is beyond the power of the
eye to see.

You may use the burnisher to get rid of certain spots produced
in the foliage by lines placed too closely together, and by the
same means you can reduce those exaggerated passages in the
stone-work of the right-hand column.

You can also burnish these useless little blotches in the moun-
tains.

52. **Charcoal**. — Whenever it is necessary to reduce the whole
of a distance, the use of charcoal is to be preferred. Charcoal
made of willow, or of other soft woods, which can be had of the
plate-makers, is used flat, impregnated with oil or water ; it must
be freed from its bark, as this would scratch the plate. It wears
the metal away uniformly, and does not injure the crispness of
the lines. Rub the passage to be reduced with the charcoal,
regulating the length of time by the degree of delicacy you desire
to attain. At the beginning soak your charcoal in water, so as
leave it more tooth ; then clean it, and continue with oil, which
reduces the wear on the copper. The eye is sufficient to judge of
the wear; the way in which the charcoal takes hold of the copper,
and the copper-colored spots which it shows, may serve as guides.
As the effectiveness of the different kinds of charcoal varies, these
divers qualities of softness and coarseness are utilized according
to the nature of the correction to be made. It is well to know,
also, that it takes hold much more actively if used in the
direction of the grain, than transversely. You may, according to
circumstances, commence with a piece of coal having considerable

tooth, continue with another that is less aggressive, and wind up with a somewhat soft piece. The heavier the charcoal the coarser its tooth, the lightest being the softest. The plate must be washed, so as to keep the charcoal always clean ; as otherwise the dust produced, which forms a paste, will wear down the bottom of the furrows, and the result, in the proof, will be dull and reddish lines.

Charcoal is also used to remove the traces of the needle in those parts of the plate in which changes were made while the drawing was still in progress.

53. **The Scraper.** — The scraper is more efficacious than the burnisher in the case of small places that have been deeply bitten. If the scraper is sufficiently sharp, it leaves no trace whatever on the lowered surface of the copper.

To sum up : —

Charcoal and *scraper* are used to remove part of the surface of the copper. The furrows, having been reduced in depth, receive less ink in printing ; the lines gain in delicacy in the impressions.

The *burnisher* simply displaces the copper ; *charcoal* and *scraper* wear it away. It follows that they must be used with discernment.

54. **Hammering Out (Repoussage).** — These three means are employed when a moderate lowering of the plate is required. When it becomes necessary to go down to half the thickness of the plate or more, the result will be a hollow, which will show as a spot in printing. In that case recourse is had to the fourth means ; that is to say, to hammer and anvil. Get a pair of compasses with curved legs (*calipers*) ; let one of the legs rest on the spot to be hammered out ; the other leg will then indicate the place on the back of the plate which must be struck with the hammer on the anvil. In this way places which have been reduced with charcoal or scraper may be brought up to the level of the plate ; but if the lines should be found to have been flattened, which would result in a dull tone in the proofs, it will be best to have the part in question planed out entirely, and to do it over.

55. **Finishing the Surface of the Plate.** — The charcoal occasionally leaves traces on the plate, which show in the proof

as rather too strong a tint. You can get rid of them, by rub-
bing with a piece of very soft linen, and the paste obtained by
grinding charcoal with oil on a fine stone.

By the same process the whole plate is tidied. It is likely to
need it, as it has undoubtedly lost some of its freshness, owing to
the abuse to which it was subjected in passing through all these
processes.

Our young pupil, having executed these several operations,
and bitten his retouched plate, submits a proof to my inspection,
which I compare with that of the first state (Pls. I^a and I.).
Now you see, I say to him, how one state leads to another. You
have come up to the harmony of the original ; your *second state*
is satisfactory, and so there is no need of having recourse to var-
nishing the plate a third time.

Pl. 1.

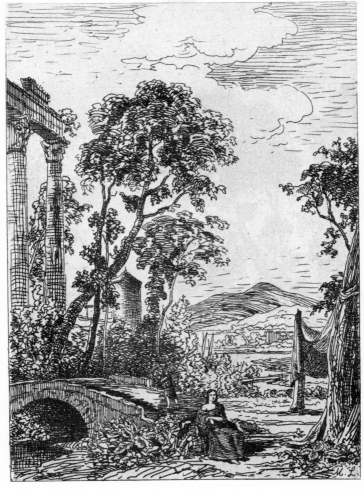

CHAPTER V.

ACCIDENTS.

56. **Stopping-out Varnish dropped on a Plate while Biting.**
— You are just in time, I continued, to profit by an accident which has happened to me. I dropped some stopping-out varnish on a plate while it was biting ; it has spread over some parts which are not yet sufficiently bitten, and of course it is impossible to go on now. I took the ground off the plate, and had this proof pulled. It is unequal in tone, and does not give the modelling which I worked for.

"What are you going to do about it ? Is the plate lost ?"

57. **Revarnishing with the Roller for Rebiting.** — Oh, no, indeed, thanks to the *roller for revarnishing!* My first precaution will be to clean the plate very carefully, first with spirits of turpentine, until the linen does not show the least sign of soiling, and then with bread. Or, having used the turpentine, I might continue the cleaning process with a solution of potash, after which the plate must be washed in pure water. I then put a little ground, specially prepared for the purpose, on a second plate, which must be scrupulously clean, and not heated ; or, better still, I apply the ground directly to the roller itself by means of a palette-knife. I divide this second plate into three parts. By passing the roller over the first part, I spread the ground roughly over it ; on the second part I equalize and distribute it more regularly ; on the third, finally, I finish the operation. By these repeated rollings a very thin layer of ground is evenly spread over all parts of the surface of the roller, and we may now apply it to the plate which is to be rebitten.

To effect this purpose, I pass the roller over the cold plate carefully and with very slight pressure, repeating the process a number of times and in various directions. This is an opera-

tion requiring skill. The ground adheres only to the surface of the plate, without penetrating into the furrows, although it is next to impossible to prevent the filling up of the very finest lines. Having thus spread the ground, and having assured myself that the lines are all right by the brilliancy of their reflection as I hold the plate against the light, I rapidly pass a burning paper under the plate. The ground is slightly heated, and solidifies as it cools.

The varnish used in this operation is the ordinary etching-ground in balls, dissolved in oil of lavender in a bath of warm water. It must have the consistency of liquid cream ; if it is too thick, add a little oil of lavender.

Both the plate and the roller must be well protected against dust.

It is not necessary to clean the roller after the operation ; only take care to wipe its ends with the palm of your hand, turning it the while, so as to remove the rings of varnish which may have formed there.

If the lines are found closed, too much pressure has been used on the roller ; if the ground is full of little holes, the plate has not been cleaned well, and wherever the surface of the copper is exposed the acid will act on it. There is nothing to be done, in both cases, but to wash off the ground with spirits of turpentine, and commence anew.

My plate is now in the same state in which it was when I withdrew it from the bath. I stop out those parts which are sufficiently bitten, and, guided by my proof, I can proceed to continue the biting which was interrupted by the accident.

58. **Revarnishing with the Roller in Cases of Partial Rebiting.** — You will find this method especially valuable whenever you desire to strengthen passages that are weak in tone. And furthermore, having thus revarnished your plate, you may avail yourself of the opportunity of giving additional finish. But if, before revarnishing, you should have burnished down some overbitten lines in a passage which needs rebiting, you will find that the shallow cavity produced by the burnisher does not take the ground from the roller ; such places are easily detected by the brilliant aspect of the copper, and good care must be taken to

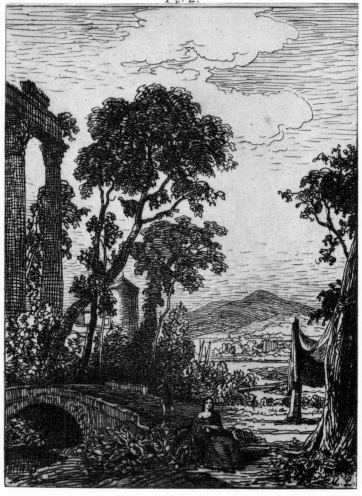
Pl. 2.

cover them with ground. Again, if, before proceeding to rebite, you should notice certain passages which are strong enough as they are, either because the copper was cut by the point, or because the lines in them are very close, you must cover them up with the brush. The same thing is necessary in the case of the excessively black spots which sometimes manifest themselves in places covered by irregularly crossing lines, and the intensity of which it would be useless to increase still further. This recommendation is valuable for work requiring precision.

59. **Revarnishing with the Dabber for Rebiting.** — For partial rebiting the same result may be reached by applying the ground with the dabber. Heat your plate, and surround the part to be rebitten with a thick coat of ordinary etching-ground. Now heat your dabber, and pass it over the ground. Finally, when the dabber is thoroughly impregnated with the ground, carry it cautiously and little by little over the part in question, dabbing continually.

60. **Revarnishing with the Brush for Rebiting.** — Let me also call your attention to an analogous case which may arise. If you desire to increase the depth of the biting in a part of the plate in which the lines are rather widely apart, you may cover the plate with the brush and stopping-out varnish, and may pass the needle through the lines so as to open them again. You can then rebite in the tray, or by using pure acid, or by allowing acid at 20° to stand on the part in question, just as you please.

61. **Rebiting a Remedy only.** — Etchers who are entitled to be considered authorities will advise you to avoid as much as possible all rebiting by means of revarnishing, as it results in heaviness, and never has the freshness of a first biting obtained with the same ground. A practised eye can easily detect the difference. Never let the rebiting be more than a quarter of the first biting. Use the process as a remedy, but never count on it as a part of your regular work.

62. **Holes in the Ground.** — Having once taken up the consideration of the little mishaps which may befall the etcher, I shall now show you another plate in which the sky is dotted by a number of minute holes of no great depth (*piqués*). This plate has, no doubt, been retouched, and the ground having been badly laid,

the acid played mischief with it. It is very lucky that the lines in the sky are widely separated, as otherwise these holes would be inextricably mixed up with them. We can rid ourselves of them by a few strokes of the burnisher, and by rubbing with charcoal-paste and a bit of fine linen. The burnisher alone would give too much polish to the copper; in printing the ink would leave no tint on the plate in these spots, and the traces of the burnisher would show as white marks in the proofs. To avoid this, the copper must be restored to its natural state.

"What would happen," asks another of my pupils, "if these little holes occurred in a sky or in some other closely worked passage? Here is a plate in which this accident has befallen some clouds and part of the ground. What shall I do?"

To begin with, let me tell you for your future guidance that this accident would not have happened if you had waited for the drying of the ground with which you covered this sky after you had bitten it. The acid, which never loses an opportunity given it by mismanagement or inattention, worked its way unbeknown to you through the soft varnish in the clouds as well as in the ground, and went on a spree at your expense. Remember that nitric acid is very selfish; it insists that it shall always be uppermost in your mind, and all your calculations must take this demand into account; its powers, creative as well as destructive, are to be continually dreaded; it likes to see you occupy yourself with it continually, watchfully, and with fear. If you turn your back to it, it plays you a trick, and thus it has punished you for neglecting it for a moment.

"Thank you. But you are acting the part of La Fontaine's schoolmaster, who moralized with the pupil when he had fallen into the water."

63. **Planing out Faulty Passages.** — And that did not help him out. You are right. Well, you must go to some skilful copper-planer, who will work away at the spoiled part of your plate with scraper and burnisher and charcoal, until he has restored the copper to its virgin state ; then all you've got to do will be to do your work over again.

"That is rather a blunt way of settling the question. Seeing that we are about to cut into the flesh after this fashion, might it

not be as well to have the whole of the sky taken out altogether ?
I am not satisfied with it, any way."

Certainly. By the same process the planer can remove every
thing, up to the outlines of the trees and the figures in your
plate ; he will cut out any thing you want, and yet respect all the
outlines, if you will only indicate your wishes on a proof. In this
passage, where you see deep holes, scraper and charcoal will be
insufficient ; the planer must, therefore, hammer them out before
he goes at the other parts. As regards the little holes in the
foreground, since they are not as deep as the lines among which
they appear, you can remove them, or at least reduce them, by
means of charcoal, without injury to the deeply bitten parts.

You may follow this plan whenever you are convinced that a
lowering of tone will do no harm to your first work. In the
opposite case, you must either have recourse to the planer, or put
up with the accident. If you are not too much of a purist, you
will occasionally find these *piqués* productive of a *piquant* effect,
and then you will take good care not to touch them.

"That's a 'point' which you did not mention among the
utensils ! You have ingenious ways of getting out of a scrape."

We cut out, or cut down, or dig away, whole passages, accord-
ing to necessity. I have seen the half of a plate planed off,
because the design was faulty.

64. **Acid Spots on Clothing.** — Here comes one of my
friends, who is also an etcher. I wonder what he brings us !
His clothing is covered all over with spots of the most beautiful
garnet ; he ought to have washed them with volatile alkali, which
neutralizes the effect of the acid. But he does not mind it.

65. **Reducing Over-bitten Passages and Crevés.** — " Oh,
gentlemen, that is not worth while speaking of ! But you must
see my plate. I drew a horse from nature, which a whole swamp-
ful of leeches might have disputed with me. But I do believe
it escaped the *biting* of these animals only to succumb to mine.
Judge for yourselves ! "

The fact of the matter is, that you have killed it with acid.
There is nothing left of it, but an informal mass, ten times over-
bitten. Fortunately there is no lack of black ink at the printer's !
It is a veritable Chinese shadow, and looks as if the horse had

gone into mourning for itself. However, although the carcass is lost, I hope you may be able to save some of the members. The wounds are deep and broad; but we can try a remedy *in extremis:* first of all, your horse will have to stand an attack of *charcoal;* if it survives this, we shall subject it to renewed and ferocious *bitings.* All this puzzles you. Therefore, having treated your beast to the charcoal, and having had a last proof taken, you place the latter before you, and re-cover your plate with a solid coat of varnish. With a somewhat coarse point you patch those places which show white in the proof, taking care to harmonize your patches with the surrounding parts.

In this way you replace the lines which have disappeared, and then proceed to bite in, doing your best to come as near as possible to the strength of the first biting. The result may not be very marvellous, but it will be an improvement, at all events. If I were in your place, I should not hesitate to begin again. The process which I have just described is best suited to isolated passages.

In closely worked and lightly bitten passages, blotches (or *crevés*) are more easily remedied, as they are less deep. Rub them down with charcoal, very cautiously and delicately, and let the dry point do the rest.

There, now! There's our friend, again, using acid instead of spirits of turpentine to clean his plate! That'll be the end of the animal. It is against the law, sir, to murder a poor, inoffensive beast this wise! Fortunately we can help him out with several sheets of blotting-paper, in default of water, which we do not happen to have at hand. We were in time! The copper has only lost its polish; a little more charcoal, — and Rosinante still lives.

Pl. 3.

Vallée d'Aspe Pyrénées à plat. une pointe.

à Séville à plat plusieurs pointes

pour couvertures plusieurs pointes
Imp Cadart

CHAPTER VI.

DIFFERENCE BETWEEN FLAT BITING, AND BITING WITH STOPPING-OUT.

66. Two Kinds of Biting.— Now that you have become famil-
iar with the secrets of biting, I say to my pupil, and are therefore
prepared to be on your guard against the accidents to be avoided
when you go to work again, I can make clear to you, better than
if I had endeavored to do so at the outset, the difference between
the two kinds of biting on which rests the whole system of the
art of etching, and the distinctive characteristics of which are often
confounded. The work thus far done will help you to a more
intelligent understanding of this distinction. As it was impossi-
ble to explain to you, at one and the same time, all the resources
of the needle as well as those of biting, between which, as I told
you before, there exist very intimate relations, I had to choose
a general example by which to demonstrate the processes em-
ployed, and which would allow me to explain the reasons for these
processes.

There are two kinds of biting, —*flat biting* and *biting with
stopping-out.* (See Pl. III.)

These two kinds of biting resemble one another in this, that
they involve only one grounding or varnishing, and consequently
only one bath ; they differ most markedly in this, that in *flat
biting* the work of the acid is accomplished all over the plate at
one and the same time, and with only one immersion in the bath,
while in *biting with stopping-out* there are several successive, or,
if you prefer the term, partial bitings, between each of which the
plate is withdrawn from the bath, and the parts to be reserved
are stopped out with varnish as often as it is thought necessary.

It follows from this, that, with flat biting, the modelling must
be done by the needle, using either only one needle, or else sev-
eral of different thicknesses.

67. **Flat Biting.—One Point.**—With a single needle the values are obtained by drawing the lines closely together in the foreground and nearer distances, or for passages requiring strength, and by keeping them apart in the off distances, and in the lighter passages of the near distances; furthermore, to obtain a play of light in the same distance, the lines must be drawn farther apart in the lights, and more closely together in the shadows. A single point gives a hint of what we desire to do, but it does not express it. It is undoubtedly sufficient for a sketch intended to represent a drawing executed with pen and ink or with the pencil; but it cannot be successfully employed in a plate which, by the variety of color and the vigor of the biting, is meant to convey the idea of a painting.

68. **Flat Biting. — Several Points. —**When several points of different thickness are used, the coarser serve for the foreground and near distances, the finer in gradual succession for the receding distances. They are used alternately in the different distances, and the lines are drawn more closely together here, or kept farther apart there, according to the necessities of the effect to be obtained; the depth of the biting is the same throughout, but the difference in thickness of the lines makes it an easy matter, by more elaborate modelling, to give to the etching the appearance of a finished design.

With a single point, as well as with several, the pressure used in drawing must remain the same throughout, so that the acid may act simultaneously, and with equal intensity on all parts of the plate. If there has been any inequality of attack, the values will be unequal in their turn, and different from what they were intended to be.

69. **Biting with Stopping-out. — One Point. —** In biting with stopping-out, it is the biting itself, and not the needle, which gives modelling to the etching. In this case, also, one or several points may be used. The simplest manner is that in which only one point is used. The stopping-out, and consequently the biting, is done in large masses. (See Pl. V. Fig. 1.)

70. **Biting with Stopping-out. — Several Points. —** As a very simple example let us take a case in which it is necessary to have certain very closely lined passages in a foreground alongside of

very coarse ones. In that case the first, or close, lines must be etched very delicately, while the whole force of the biting must be brought to bear on the latter (see Pl. IV. Fig. 2). In the same way the values of two different objects may be equilibrated ; by employing close lines slightly bitten in the one case, and spaced lines more deeply bitten in the other. Biting with stopping-out, combined with the work of several points, requires more attention and discernment than any other.

If the first biting is not successful, the plate is revarnished, and the work of repairing and correcting commences.

Summing up the advantages offered by these various means, you will see what results the combination of the work of one or of several points with partial biting may be made to yield, either in giving to objects their various values, their natural color, and their modelling, or in disposing them in space, and thus producing the harmonious gradation of the several distances.

71. **Necessity of Experimenting.** — If you will now call to mind our preceding operations, and will hold them together with the explanations just given, you will be able to appreciate them in their totality. The necessity of arriving at truth of expression, with nothing to guide you but these rules, which are influenced by a variety of conditions, will compel you to experiment for yourself, with special reference to the combination of *the surrounding temperature, the strength of the acid, the number of partial bitings, the pressure of the point, the different thicknesses of the points,* and *the various kinds of work that can be done with them,* on the one hand ; and on the other, with regard to *the length of the bitings.* If you are called upon to imitate a given object very closely, you must proceed rationally, and your work must be accompanied by continual reflection. To familiarize yourself with these delicate operations, you must experiment for yourself; don't complain if you spoil a few plates ; you will learn something by your failures, as your experience in one case will teach you what to do in others. Self-acquired experience is of all teachers the best.

72. **Various other Methods of Biting.** — The two preceding methods, which, in a general way, comprehend the rules of biting, do not exclude other particular methods of a similar nature. Thus, it may be well sometimes to etch at first only the sim-

ple outline, biting it in more or less vigorously, according to
the nature of the case (see Pl. IV. Fig. 3) ; and then, having
revarnished and resmoked the plate, to elaborate the drawing by
going over it either in some parts only or throughout the whole.
Rembrandt often pursued this course ; and we may follow the
several stages of his work by studying the various states of his
plates. We see that he took great pains to work out some part
of his subject very carefully, without touching the other parts ;
he then took a proof, and afterwards went over the same part
with finer lines, and passed on to the other parts, treating them
according to the effect which he desired to reach.

This method is often imitated ; it is employed when it is neces-
sary to lay a shadow over a passage full of detail, as, for instance,
in architectural subjects, in the execution of which it is easier,
and tends to avoid confusion, to fix the lines of the design first,
and then, having laid the ground a second time, to add the
shadows. (See Pl. IV. Fig. 4.)

" Pardon me ! But might not this result be obtained by the
same biting, if the lines of the design were drawn with a coarse
point, and the shading were added with a finer one ? "

Certainly ; and in that case we should have an instance of
work executed with several needles, such as I pointed out to you
before.

From the explanations previously given, it will be clear, also,
that, the nature of the subject permitting, it may be advantageous
sometimes to execute a plate by drawing and biting each dis-
tance by itself. Thus you may commence with the foreground,
and may bite it in ; having had a proof taken, revarnish your
plate, and proceed in the same fashion to the execution of the
other distances, and of the sky, always having a proof taken after
each biting to serve you as a guide.

This mode of operation — essentially that of the engraver —
is of special advantage in putting in a sky or a background
behind complicated foliage. You can draw and bite your sky or
your background all by itself (see Pl. IV. Fig. 5), and then, having
revarnished your plate, you can execute your trees on the back-
ground. As the trees are bitten by themselves, it is evident
that we have avoided a difficulty which is almost insurmountable,

Pl. 4

Fig. 1.

Fig. 2.

Fig. 3.

Fig. 4.

Fig. 5.

M. L.

Imp. Delâtre.

— that, namely, of stopping out with the brush the lines of the sky between intricate masses of foliage. But we can also proceed differently. We can commence with the trees, drawing them and biting them in, and can finish with the sky, having revarnished the plate as usual : the sky will thus fall into its place behind the trees. You need not trouble yourself because the lines of the sky pass across the lines of the trees. The biting of the sky must be so delicate that it will not affect the value of the foliage, and you may therefore carry your point in all directions, and use it as freely as you please.

Some etchers find it more convenient to commence with the sky and the background, on account of the points of resistance encountered by the needle in the more deeply bitten lines of the trees, which destroys their freedom of execution. They are correct, whenever the sky to be executed is very complicated ; but if only a few lines are involved, it will be better to introduce them afterwards. It is, besides, an easy matter to get accustomed to the jumping of the point when it is working on a ground that has previously been bitten.

What I have just told you applies also to the masts and the rigging of vessels, &c., and, indeed, to all lines which cut clearly and strongly across a delicately bitten distance.

An etcher of great merit has conceived the original idea of executing an etching in the bath itself, commencing with the passages which need a vigorous biting, then successively passing on to the more delicate parts, and finally ending with the sky.* The various distances thus receive their due proportion of biting; but it is necessary to work very quickly, as the biting of a plate etched in the bath in this manner proceeds five to six times more rapidly than if done in the ordinary manner. Every etcher ought to be curious to try this bold method of working, so that he may see how it is possible to ally the inspiration of the moment with the uncertain duration of the biting, which in this process has

* The bath, in this case, is composed as follows : —

880 gr. water.
100 " pure hydrochloric (muriatic) acid.
20 " potassium chlorate.

emancipated itself from all methodical rule, and follows no law but that imposed upon it by the caprice of the artist.

All this goes to show you that there is ample liberty of choice as to processes in etching. It is well to try them all, as it is well to try every thing that may give new and unknown results, may inspire ideas, or may lead to progress, neither of which is likely to happen in the pursuit of mere routine work.

CHAPTER VII.

RECOMMENDATIONS AND AUXILIARY PROCESSES.—ZINK AND
STEEL PLATES.—VARIOUS THEORIES.

A. RECOMMENDATIONS AND AUXILIARY PROCESSES.

73. **The Roulette.** — The latitude which I gave you does not extend to the point of approving of all material resources without any exception. There is one which I shall not permit you to make use of, as the needle has enough resources of its own to be able to do without it. I allude to the *roulette*, which finds its natural application in other species of engraving.

74. **The Flat Point.** — Employ the *flat point* with judgment; it takes up a great deal of varnish, but gives lines of little depth, and of less strength than those which can be obtained by prolonged biting, with an ordinary needle.

75. **The Graver or Burin.** — "And the graver: what do you say to that?"

The graver is the customary and fundamental tool of what is properly called "line-engraving." Although it is not absolutely necessary in the species of etching which we are studying, there are cases, nevertheless, in which it can be used to advantage, but always as an auxiliary only.

If, for instance, you desire to give force to a deeply bitten but grayish and dull passage, or to a flat tint which looks monotonous, a few resolute and irregular touches with the graver will do wonders, and will add warmth and color. A few isolated lines with the graver give freshness to a muddy, broken, or foxy tint, without increasing its value.

The graver may also be employed in patching deeply bitten passages.

The graver, of a rectangular form, with an angular cutting edge, is applied almost horizontally on the bare copper; its handle,

rounded above, flat below, is held in the palm of the hand ; the index finger presses on the steel bar ; it is pushed forward, and easily enters the metal : the degree of pressure applied, and the angle which it makes with the plate, produces the difference in the engraved lines. The color obtained by the burin is deeper than that obtained by biting, as it cuts more deeply into the copper. If extensively used in an etching, the work executed by the graver contrasts rather unpleasantly with the quality of the etched work, as its lines are extremely clear cut. To get rid of this inequality, it is sufficient to rebite the passages in question very slightly, which gives to the burin-lines the appearance of etched lines.

In short : use the graver with great circumspection, as its application to works of the needle is a very delicate matter, and gives to an etching a character different from that which we are striving for. It seems to me that to employ it on a free etching, done on the spur of the moment, would be like throwing a phrase from Bossuet into the midst of a lively conversation.

76. **Sandpaper.** — As regards other mechanical means, be distrustful of tints obtained by rubbing the copper with sandpaper ; these tints generally show in the proof as muddy spots, and are wanting in freshness. Avoid the process, because of its difficulty of application. Only a very skilful engraver can put it to good uses.

77. **Sulphur Tints.** — I shall be less afraid to see you make use of *flowers of sulphur* for the purpose of harmonizing or increasing the weight of a tint. The sulphur is mixed with oil, so as to form a homogeneous paste thick enough to be laid on with a brush.

By the action of these two substances the polish on the plate is destroyed, and the result in printing is a fresh and soft tint, which blends agreeably with the work of the needle.

Differences in value are easily obtained by allowing the sulphur to remain on the plate for a greater or less period of time. This species of biting acts more readily in hot weather ; a few minutes are sufficient to produce a firm tint. In cold weather relatively more time is needed. The corrosions produced in this way have quite a dark appearance on the plate, but they produce much lighter tints in printing. If you are not satisfied with the result

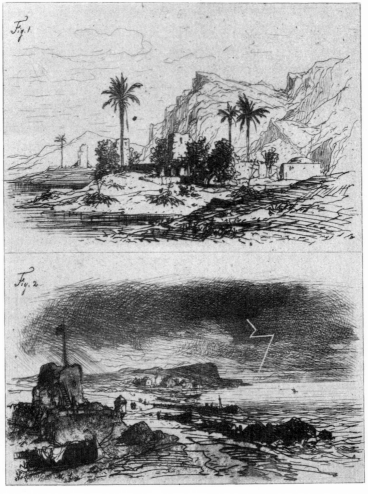

Pl. 5.

Fig. 1

Fig. 2

obtained, you can rub it out with charcoal, as the copper is corroded only quite superficially.

Owing to this extreme slightness of biting, the burnisher may also be used to reduce any parts which are to stand out white.

This process, as you see, is very accommodating; but it is too much like mezzotint or aquatint, and, furthermore, it can only be applied in flat tints, without modelling. I have, nevertheless, explained it to you, so that you may be able to use it, if you should have a notion to do so, as a matter of curiosity, but with reserve. It is better to use the dry point, which has more affinity to the processes natural to etching.

78. **Mottled Tints.**—You may also make use of the following process (but with the same restrictions) in the representation of parts of old walls, of rocks and earth, or of passages to which you desire to impart the character of a sort of artistic disorder :— Distribute a quantity of ordinary etching-ground on a copper plate sufficiently heated ; then take your dabber, and, having charged it unequally with varnish, and having also heated your etched plate, press the dabber on the passages which are to receive the tint ; the varnish adheres to the plate in an irregular manner, leaving the copper bare here and there. Now stop out with the brush those parts which you desire to protect, and bite in with pure acid ; the result will be a curiously mottled irregular tint (see Pl. V. Fig. 2). Properly used in the representation of subjects on which you are at liberty to exercise your fancy, this process will give you unexpected and often happy results.

79. **Stopping-out before all Biting.** — Before we proceed, I must show you an easy method of representing a thunder-storm (see Pl. V. Fig. 2) : — Work the sky with the needle, very closely, so as to get the sombre tints of the clouds ; and, before biting, trace the streaks of lightning on the etched work with a brush and stopping-out varnish ; being thus protected against the acid, these streaks will show white in the printing, and the effect will be neater and more natural than if you had attempted to obtain it by the needle itself, as you will avoid the somewhat hard outlines on either side of the lightning, which would otherwise have been necessary to indicate it.

You can employ the same process for effects of moonlight, for

reflected lights on water, and, in fact, for all light lines which it is difficult to pick out on a dark ground.

B. ZINK PLATES AND STEEL PLATES.

80. Zink Plates. — So far I have spoken to you of copper plates only ; but etchings are also executed on *zink* and on *steel*. Zink bites rapidly, and needs only one quarter of the time necessary for copper, with the same strength of acid ; or, with the same length of time, an acid of ten degrees is sufficient. The biting is coarse, and without either delicacy or depth. A zink plate prints only a small edition.

81. Steel Plates. — Steel also bites with great rapidity. One part of acid to seven of water is sufficient ; and the biting is accomplished, on the average, in from one to five minutes, from the faintest distance to the strongest foreground.

Free, artistic etchings are very rarely executed on steel, which is more particularly used in other kinds of engraving.

C. VARIOUS OTHER PROCESSES.

82. Soft Ground Etching. — There is a kind of etching known as *soft-ground etching*, and but little practised at present, which was successfully cultivated about thirty years ago by Louis Marvy and Masson. The engravers of the last century used to call it *gravure en manière de crayon.*

Take a ball of common etching-ground, and melt it in the water-bath in a small vessel, adding to it, in winter, an equal volume, and in summer only one-third of the same volume, of tallow. Let the mixture cool, form it into a ball, and wrap it up in a piece of very fine silk. Ground your plate in the usual way, and smoke lightly. On this soft ground fix a piece of very thin paper having a grain, and on the paper thus attached to the plate, execute your design with a lead-pencil. Wherever the pencil passes, the varnish sticks to the paper in proportion to the pressure of the hand ; and, on carefully removing the sheet, it takes up the varnish that adheres to it. Bite the plate, and the result will be a facsimile of the design executed on the paper. (See Pl. VI.)

If the proofs are too soft, or wanting in decision, the plate may

Pl. 6.

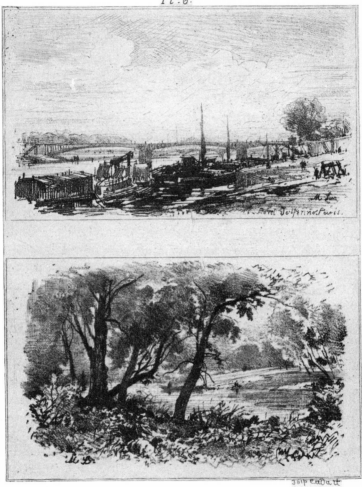

Pont Solferino Paris.

Imp Cadart

be worked over with the needle, by regrounding, and then rebit-
ing it. The first state can thus be elaborated like an ordinary
etching, and the necessary precision can be given to it whenever
the idea to be expressed is vaguely or insufficiently rendered ; or
the same end may be reached by the dry point. In either case,
however, all the retouches must be executed by irregular stippling,
so that they may harmonize with the result of the first biting.
Otherwise there will be a lack of homogeneity in the appearance
of etchings of this sort, in which the grain of the paper plays an
important part. Smooth paper gives no result whatever. The
paper used may have a coarse grain or a fine grain, at the pleas-
ure of the etcher, or papers of different grain may be used in the
same design. This style of etching requires great care in han-
dling the plate, on account of the tenderness of the ground. In
drawing, a *hand-rest* must be used, so that the hand may not
touch the plate.

83. **Dry Point Etching.** — The *dry point* is also used for etch-
ing, without the intervention of the acid-bath. The design is
executed with the dry point on the bare copper ; the difference in
values is obtained by the greater or less amount of pressure used,
and by the difference in the distance between the lines. (See
Plate VII.) The brilliancy of effect which etchings of this kind
may or may not possess, depends on the use made of the *scraper*
(see paragraph 49, p. 33).

You will find it convenient to varnish and smoke your plate, to
begin with, and to trace the leading lines of your design on the
ground, taking care to cut lightly into the copper with the point.
Then remove the varnish, and continue your drawing, guided by
these general outlines.

It is best to commence with the sky, or other delicate passages,
and to remove the bur from them, if there are other stronger
lines to be drawn over them.

You can see perfectly well what you are doing, by rubbing a
little lamp-black mixed with tallow into the lines as you proceed,
and cleaning the plate with the flat of your hand ; in this way
you can control your work, and can carry it forward until it is
finished, either by removing more or less of the bur, or by allow-
ing all of it to stand, or by the elaboration of those passages which

seem to need it. The lines show on the plate as they are intended to show on the paper. You can therefore bring out your subject by shading ; you can lay vigorous lines over lines from which the bur has been removed ; you can take out, and you can put in. The effect produced in the printing is velvety and strong, similar to that produced by the stump on paper. Rembrandt employed the dry point, without scraping, in some of his principal etchings.

84. **The Pen Process.** — I must now speak to you of a process which offers certain advantages. Clean your plate thoroughly, first with turpentine, and then with whiting, and take care not to touch the polished surface with your fingers. Execute a design on the bare copper with the pen and ordinary ink. You must not, of course, expect to find in the pen the same delicacy as in the needle.

The design having been finished and thoroughly dried, ground and smoke your plate without, for the present, taking any further notice of the design ; but be sure to see to it that the coat of varnish is not too thick ; then lay the plate into water, and let it stay there for a quarter of an hour. Having withdrawn the plate, rub it lightly with a piece of flannel ; the ink, having been softened by the water, comes off, together with the varnish which covers it, and leaves the design in well-defined lines on the copper, which you may now bite.

You may work either with one pen and several bitings, or with several pens of various degrees of fineness and one biting.

As in the case of soft ground etching, you may make additions with the needle to give delicacy.

It is necessary to ground the plate and to soak it in water as soon as may be after the finishing of the design. At the end of two days, the ink refuses to rub off.

Pl. 7.

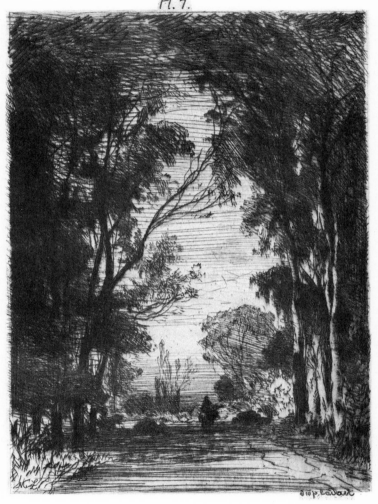

CHAPTER VIII.

PROVING AND PRINTING.

85. **Wax Proofs.** — Our first desire, after the ground has been removed from the plate, is to see a proof. If you have no press, and yet desire to take proofs of your work after each biting, you may employ the following process to good advantage : —

Take a sheet of very thin paper, a little larger than your plate, and cover it with a thin layer of melted wax. The latter must be real white wax. Then sprinkle a little lamp-black on your engraved plate, and distribute it with your finger, so as to rub it into the lines ; clean the surface of the plate by carefully passing the palm of your hand over it. Now lay the sheet of paper on the plate, with its waxed surface down, and be sure to turn the edges of the paper over on the back of the plate, so as to prevent its moving ; then rub with the burnisher in all directions. The lamp-black sticks to the wax, and is sure to give an approximate image, sufficient to guide you in the further prosecution of your work, if that should be necessary.

86. **The Printing-Press.** — These proofs, however, as well as those which were hurriedly printed for you so far, give only a mere idea of your work, without conveying its full meaning. If you desire to become acquainted with all the resources of the printing-press, you will have to go to a plate printer. It is well worth your while to acquire this knowledge, also, after you have familiarized yourself with the various processes at the command of the etcher.

Here, then, is the printer at his press : at his side there is a box made of sheet-iron, enclosing a chafing-dish ; there are also printing-ink, a ball for inking, rags, and paper. He is about to explain the use made of these things to our young student, who delivers his plate to him, and is anxious to be instructed in all that relates to the taking of impressions.

87. Natural Printing. — The printer now begins his explanations as follows : —

I place the plate on the sheet-iron box (the plate-warmer) ; it there acquires the necessary degree of heat, and I then spread the printing ink over it by means of this ball ; the ink penetrates into the lines, and completely covers the whole surface of the plate ; I remove the excess of ink with a coarse muslin rag, precisely as this is done in all other kinds of plate printing ; I now clean the plate with the palm of my hand, so that no ink is left on it anywhere but in the lines ; I finally wipe the margins of the plate evenly, so as to leave a delicate tint on the etched part only, and then I put the plate into the press. The plate is laid on the travelling board or bed of the press, which runs between two cylinders of iron or hard wood ; on the plate I lay a piece of paper, slightly moistened, and I cover the whole with several thicknesses of flannel ; I turn the wheel of the press, and the cylinders, turning on themselves, carry along the travelling-board, which, in passing between them, is subjected to great pressure. The paper is thus pressed into the lines on the plate, and this process is facilitated by the elasticity of the flannel. You see now that your plate has come out on the other side of the rollers (or cylinders) : we have given the press only one turn, although, as a rule, the plate is passed through the press twice, by making it travel back again under the rollers. This imparts strength to the impression ; but occasionally the lines are not rendered as delicately and with as much precision, as with only one turn. I remove the flannel, and very carefully lift the paper ; it has absorbed the ink : we have before us a *natural proof*, which shows the exact state of the plate (see Pl. I.). Line-engravings are printed in the same manner ; with this difference, however, that the tint, more or less apparent, which is preserved on an etching, is not allowed to remain on a plate engraved with the burin.

88. Artificial Printing. — The printing of etchings very frequently differs from the simple method just described. It must be varied according to the style of execution adopted by the etcher ; and, as much of the harmony of the plate may depend upon it, it sometimes rises to the dignity of an art, in which the

artist and the printer are merged into each other,—the printer losing himself in the artist, as he is compelled to enter into the latter's ideas ; and the artist giving way to the printer, to avail himself of his practical experience. The proof from your plate, for instance, has a dry look (see Pl. I.) ; it needs more softness, and this can be given to it by the printer.* (See Pl. II.)

I will now explain to you some of the various artifices which are employed in printing.

89. **Handwiping with Retroussage.**—Having *wiped the plate with the palm of the hand*, we might *bring it up again (la retrousser)* by playing over it very lightly with a piece of soft muslin rag rolled together. The muslin draws the ink out of the lines, and spreads it along their edges, so that, in the proof, the space between the lines is filled up by a vigorous tint. But this process can only be used on plates in which the lines are evenly disposed throughout, and, more especially, scattered. To produce the proper effect the *retroussage* must be general ; because, if the rag passes over one passage only, and not over the others, or, if it is brought into play only on the dark parts, and not in the lights, there will be discordance of tone, and consequently want of harmony. In the present case, therefore, *retroussage* would be unsatisfactory, because the work on your plate, while it is broadly treated in some parts, is so close in others that there is no room left between the furrows. It follows that there is no place for the ink, drawn out of the lines, to spread on ; the result would be a muddy tint,—one of those overcharged impressions which bring criticism upon the printer, because he has applied *retroussage* to a plate which did not need it.

90. **Tinting with a Stiff Rag.**—Let us now try another means. The proof will gain in freshness if we soften the lines by going over the plate, *after it has been wiped with the hand*, somewhat more heavily with *stiff muslin.* Owing to the pressure used, the rag, instead of carrying away the ink which it has taken up

* It would be a great advantage if every etcher could print his own proofs. Rembrandt is the most striking example, as he was the author of many of the devices in use even to-day. A press can easily be procured. The firm of Ve. Cadart, Paris, has had a little portable press constructed, especially for the use of artists and amateurs. All the necessary accessories for printing can also be obtained of this firm. (See Note 22.)

out of the lines, retains it ; a tint like that produced by the stump is spread over the plate, and envelops the lines without obscuring them ; the proof is supple and velvety. (See Pl. II.)

91. **Wiping with the Rag only.** — Here is another variety. I am just printing a number of original plates by different artists. Being true painter's etchings, some of these plates are boldly accentuated and heavily bitten ; the lines are widely apart, and significant. If these plates were printed *naturally*, they would yield bare and poor-looking proofs. Wiping with the hand would be useless. I therefore go over the plate with *stiff* muslin. In the same manner I continue and finish, so as to give the greatest amount of cleaning to the luminous passages, while a tolerably strong tint is left on the dark and deeply bitten ones.

Or I might have wiped the plate energetically with soft muslin, and then might have brought up again certain passages with a soft and somewhat cleaner rag.

This method of wiping, which leaves on the surface of the plate a tint of more or less depth, must not be confounded with *retroussage*. Here is a proof of one of the plates of which I spoke to you : it is well sustained at all points ; the lines are full and nourished; the general aspect is harmonious and energetic; the lights are softened ; the strongly marked passages are enveloped in a warm tint. One might almost say that the effect of painting has been carried into etching.

This method is employed for plates which have been deeply bitten, but upon which stopping-out has been used but sparingly, for works in which there is sobriety of expression, or for sketches (see Pl. VIII.). It is all the more necessary, sometimes, for the printer to take the initiative, the simpler the plate has been etched ; it is left to him, in short, to complete the intention merely indicated by the artist.

92. **Limits of Artificial Printing.** — These examples have shown to you that difference in tone depends on the amount of pressure, and the variety of texture in the muslin. It is oftentimes necessary — and this is an affair of tact — to make use of these diverse qualities of the muslin on the same plate, — now reducing an over-strong tint by more vigorous wiping ; now giving renewed force to it, in case it has become too soft.

PL. 8.

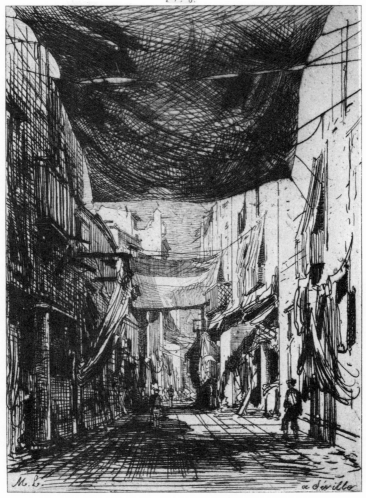

M. L. a Séville

These various means constitute the art of printing etchings. But, while fully recognizing their efficiency when they are used to the purpose, we must also keep in mind the dangers which arise from their being applied without discernment. Plates produced by an intelligent combination of bitings, must be printed naturally, if they are not to lose the absolute character given to them by the needle and the acid. If they are at all wiped with the rag, so as to impart more softness to them, it must, at least, be done with the greatest of care.

The artist has every thing to gain, therefore, by watching over the printing of his plates, and instructing the printer as to the manner in which he desires to be interpreted. Some etchers prefer the simplicity of the natural state ; but the great majority favor the other method of printing, which, for the very reason that it is difficult, and on account of the many variations in its application, ought always to be an object of interest to the printer, and the aim of his studies. It is, moreover, the method which is generally understood and adopted by our first etchers.

93. **Printing Inks.** — The quality and the shade of the ink, as well as the way in which it is ground, are of great importance in the beauty of a proof. Inks are made of pure black, slightly tempered with bistre or burnt sienna, and the shade can be varied according to taste. A plate like yours needs a delicate black, composed of Frankfort black and lamp-black ; the bistre-tint, which, in the course of time, loses its freshness and strength, would not answer. This tint is always best suited to strongly bitten work, but in your case it would be insufficient. A very strong black, on the other hand, would make your etching look hard. This last shade — pure, or very slightly broken with bistre — is preferable for strongly accented plates.

94. **Paper.** — *Laid paper* is the most suitable paper for printing etchings ; its sparkle produces a marvellous effect ; its strength defies time itself.

Some artists and amateurs ransack the shops for old paper with brown and dingy edges, which, to certain plates, imparts the appearance of old etchings.

India paper (*Chinese paper*) promotes purity of line ; but, as its surface is dull, it furnishes somewhat dry and dim proofs.

Japanese paper, of a warm yellowish tint, silky and transparent, is excellent, especially for plates which need more of mystery than of brilliancy, for heavy and deep tones, and for concentration of effect. Japanese paper absorbs the ink, and it is necessary, therefore, to bring up (*retrousser*) the plate strongly, and to wipe it with the rag. This paper is less favorable to sketches, the precise, free, and widely spaced lines of which accommodate themselves better to the tint of the laid paper.

Parchment may also be used for proofs; nothing equals the beauty of such proofs, printed either naturally, or wiped with the rag; they are the treasures of collectors.

95. **Épreuves Volantes.** — On Chinese and Japanese paper, as well as on parchment, so-called *épreuves volantes* (flying proofs) are printed; that is to say, loose proofs, which are not pasted down on white paper. They are simply attached to Bristol board by the two upper corners, which brings them out perfectly.

96. **Proofs before Lettering.** — All of these various kinds of paper, each of which has its own claim for excellence, and especially Japanese paper, are by preference used for artists' proofs and proofs before lettering, which are printed before the title is engraved on the plate. It is customary to print a greater or less number of such proofs, which, being struck off when the plate is still quite fresh, show it at its best. After that, the plate is lettered, and an ordinary edition is printed from it.

It follows from this that the possessor of a proof without title has the best the plate can afford to give. But, as the pictures by the masters do not stand in need of a signature to be recognized, so the proofs before lettering may well do without the guaranty which is found in the absence of a title; even without this guaranty an amateur knows how to recognize the virgin freshness of an early impression, which is still further augmented by the extreme care bestowed on the printing of these exceptional proofs, but which cannot be kept up through a long edition.

97. **Épreuves de Remarque.** — *Épreuves de remarque* (marked proofs), showing the different states of the plate, and the various modifications which it underwent, are also sought after. Their rarity increases their price.

98. **Number of Impressions which a Plate is capable of**

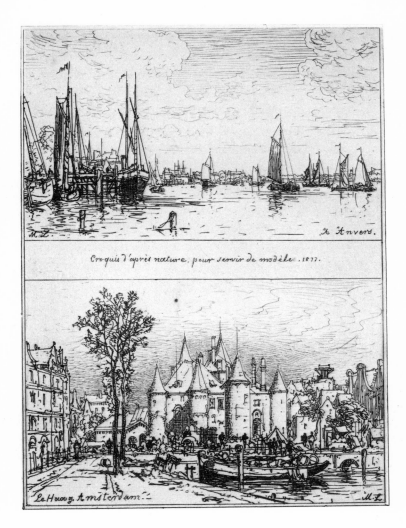

À Anvers.

Croquis d'après nature, pour servir de modèle. 1877.

Le Houg. Amsterdam.

yielding. — The number of impressions which a plate can yield is not fixed, as the power of resisting the wear and tear of printing depends largely on the delicacy or the strength of the work. The quality of the copper must also be considered, a soft plate giving way much faster than a hard plate which has been well hammered. The plates prepared to-day do not resist as well as those formerly made ; and as the popularity of works of art multiplied by the press has considerably increased, it became necessary to look about for means by which the surface of a copper plate may be hardened, and be made to yield a large edition. This has been accomplished by

99. **Steel-facing.** — *Steel-facing*, which was invented by Messrs. Salmon and Garnier, and which M. Jacquin undertook to render practicable, consists in depositing a coating of veritable steel, by galvanic action, on the face of the copper plate, or, in other words, by the superposition of a hard metal on a soft metal.

This mode of protection, which perfectly preserves the most delicate passages, even down to the almost invisible scratches of the dry point, not only guarantees the copper against the contact of the hand and the rag, which would tell on it more than the pressure of the rollers, but at the same time makes it possible to print a thousand proofs of equal purity. Certain plates, owing to the manner of wiping used on them, do not reach this figure ; others, more simply printed, may yield three to four thousand proofs, and sometimes even a still larger number.

As soon as the plate shows the slightest change, or the copper begins to reappear, the coating of steel is removed by chemical agents, which, acting differently on the two metals, corrode the one, while they leave the other untouched. The plate is thus brought back to its original state, and is therefore in the same condition as before to receive a second steel-facing. In this way plates may be *de-steeled* and *re-steeled* a great many times, and the proofs printed from them may be carried up to considerable quantities.

As a rule, the plates are not steel-faced until after the proofs before lettering have been printed.

Soft-ground etchings, the biting of which is quite shallow, must be steel-faced after two to three hundred impressions.

The delicacy of the bur thrown up by the dry point hardly permits the printing of more than twenty or thirty proofs on an average; steel-facing carries this number up to a point which cannot be fixed absolutely, but it is certain that the bur takes the steel quite as well and as solidly as an etched line. Dry points may, therefore, yield long editions; the steel-facing must in that case be renewed whenever necessary.

100. **Copper-facing Zink Plates.** — Zink plates cannot be steel-faced, but they can be copper-faced. Steel-facing has been adopted by the Chalcographic Office of the Louvre, and by the *Gazette des Beaux Arts*, that remarkable and unique publication which is an honor to criticism and is found in all art libraries. Steel-facing, in fact, is universally employed; it preserves in good condition the beautiful plates of our engravers, and makes it possible to put within reach of a great many people engravings of a choice kind, which but lately were found only in the *salons* of the rich and the collections of passionate amateurs.

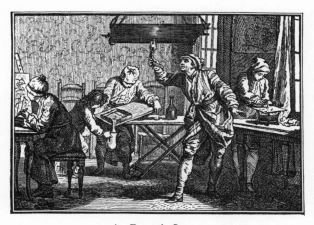

AN ETCHER'S STUDIO.
From the Third Edition of Abraham Bosse's "Treatise," Paris, 1758.

LIST OF WORKS

ON THE

PRACTICE AND HISTORY OF ETCHING.*

———◆———

A. TECHNICAL TREATISES.

De la gravure en taille-douce, à l'eau-forte et au burin, ensemble la manière d'en imprimer les planches et d'en construire la presse, par ABRAHAM BOSSE. Paris, 1645.

Traité des manières de graver en taille-douce sur l'airain par le moyen des eaux-fortes et des vernis durs et mols, par le s. ABRAHAM BOSSE, augmenté de la nouvelle manière dont se sert M. LECLERC, graveur du roi. Paris, 1701.

* *De la manière de graver à l'eau-forte* et au burin, et de la gravure en manière noir . . . par ABRAHAM BOSSE. Nouvelle édition. . . . Paris, 1758. Small 8vo. Ill.

* *Die Kunst in Kupfer zu stechen* sowohl mittelst des Aetzwassers als mit dem Grabstichel . . . durch ABRAHAM BOSSE. . . . Aus dem Französischen ins Deutsche übersetzt. Dresden, 1765. Small 8vo. Ill.

The Art of Graveing and Etching, wherein is exprest the true Way of Graveing in Copper ; allso the Manner and Method of that famous Callot, and M. Bosse, in their several Ways of Etching. Published by WILLIAM FAITHORNE. London, 1662. 8vo. Ill.

Idée de la gravure, par M. DE M * * *. Without place or date. 12mo. (This essay appeared originally in the " Mercure" for April, 1756, and was afterwards printed separately. See, also, in the "Mercure" for 1755, a notice, announcing the publication of a print by de Marcenay de Ghuy after the elder Parrocel. This notice was also printed separately.)

* This list is very far from being complete, especially in the last section, " Individual Artists." I have made a few additions, which have been marked by an asterisk. Those who desire to pursue the subject will find a very full bibliographical list in J. E. WESSELY's *Anleitung zur Kenntniss und zum Sammeln der Werke des Kunstdruckes,* Leipzig, Weigel, 1876, p. 279 et seq. — *Translator.*

Idée de la gravure . . . par M. DE MARCENAY DE GHUY. Paris, 1764. In -4 de 16 et 10 pag. (This is a second edition of the work last mentioned.)

* *Anleitung zur Aetzkunst* . . . nach eigenen praktischen Erfahrungen herausgegeben von JOHANN HEINRICH MEYNIER. Hof, 1804. 8vo. Ill.

Lectures on the Art of Engraving, delivered at the Royal Institute of Great Britain, by JOHN LANDSEER, Engraver to the King. London, 1807. 8vo.

Three Lectures on Engraving, delivered at the Surrey Institution in the Year 1809, by ROBERT MITCHELL MEADOWS. London, 1811. 8vo.

Manuel du graveur, ou Traité complet de la gravure en tous genres, d'après les renseignements fournis par plusieurs artistes. Par A. M. PERROT. Paris, 1830. In -18.

Des mordants, des vernis et des planches dans l'art du graveur, ou Traité complet de la gravure. Par PIERRE DELESCHAMPS. Paris, 1836. In -8.

* *Vollständiges Handbuch der Gravirkunst*, enthaltend gründliche Belehrungen über die Aetzwässer, die Aetzgründe, die Platten und die Gravirmaschinen. . . . Von PET. DELESCHAMPS. Deutsch, mit Zusätzen, von Dr. CHR. H. SCHMIDT. Quedlinburg und Leipzig, Basse, 1838. Ill.

The Art of Engraving, with the various Modes of Operation. . . . By T. H. FIELDING. London, 1844. 8vo. Ill.

Lettre de Martial sur les éléments de la gravure à l'eau-forte. Paris, 1864. (Etched on 4 fol. plates, illustrated.)

Nouveau traité de la gravure à l'eau-forte à l'usage des peintres et des déssinateurs, par A. P. MARTIAL. Paris, A. Cadart. 1873. Ill.

* *The Etcher's Handbook :* giving an Account of the Old Processes, and of Processes recently discovered. By PHILIP GILBERT HAMERTON. London, Roberson, 1871. Ill. (See also Mr. Hamerton's *Etching and Etchers*, 2d edition.)

* *Mr. Seymour Haden on Etching*. Lectures delivered at the Royal Institution, reports of which were published in "The Magazine of Art," 1879, and in the London "Building News," 1879.

* *The Etcher's Guide*. By THOMAS BISHOP. Philadelphia, Janentzky, 1879. Ill.

Grammaire des Arts du Dessin, par CHARLES BLANC. In this work (of which there is also an English translation), there is a special chapter on Etching.

Charles Jacque. Articles by him on Etching in the "Magasin pittoresque."

Gravure. — Article extrait de l'Encyclopédie des arts et métiers. In – fol, de 9 pag., fig.

B. Historical and Theoretical.

* *Anleitung zur Kupferstichkunde.* Von ADAM VON BARTSCH. Wien, 1821. 2 vols. 8vo. Plates.

Des types et des manières des maîtres graveurs, pour servir à l'histoire de la gravure en Italie, en Allemagne, dans les Pays-Bas et en France, par JULES RENOUVIER. Montpellier, 1853–1856. 4 parties in –4.

La gravure depuis son origine, par HENRI DELABORDE. 1860. (These articles appeared in the *Revue des Deux Mondes* for Dec. 1 and 15, 1850, and Jan. 1, 1851.)

Histoire de la gravure en France, par GEORGES DUPLESSIS. Paris, 1861. In –8. (This work was crowned by the French Institute [Académie des beaux-arts].)

Etching and Etchers. By PHILIP GILBERT HAMERTON. London, Macmillan, 1868. 4to. Ill.

* *Etching and Etchers.* By PHILIP GILBERT HAMERTON. (Second edition.) 1876. London, Macmillan. Boston, Roberts Bros.

* *The Origin and Antiquity of Engraving.* . . . By W. S. BAKER. Boston, Osgood, 1875. 4to. (Second edition. Ill.)

La Gravure à l'eau-forte, essai historique par RAOUL DE SAINT–ARROMAN. — *Comment je devins graveur à l'eau-forte,* par le comte LEPIC. Paris, Cadart, 1876.

* *Anleitung zur Kenntniss und zum Sammeln der Werke des Kunstdruckes,* von J. E. WESSELY. Leipzig, Weigel, 1876. 8vo.

* *About Etching.* Part I. Notes by Mr. SEYMOUR HADEN on a Collection of Etchings by the Great Masters. . . . Part II. An Annotated Catalogue of the Etchings exhibited. 148 New Bond Street (London), 1879. (Second edition, which has some additions.)

* *About Etching.* By SEYMOUR HADEN. Illustrated with an original etching by Mr. Haden, and fourteen facsimiles from his collection. Imperial 4to. London, The Fine Art Society, 1879.

C. Catalogues of the Works of the Artists.

(*a.*) DICTIONARIES.

Le peintre-graveur, par ADAM BARTSCH. Vienne, 1803–1821. 21 vol. in –8 et un atlas in –4.

* *Le peintre-graveur.* Par J. D. PASSAVANT. Leipzig, 1860. 6 vols. 8vo. (Continuation of Bartsch's work.)

Le peintre-graveur français, . . . par ROBERT DUMESNIL. Paris, 1835–1874. 11 vol. in –8.

Le peintre-graveur français continué, par PROSPER DE BEAUDICOUR. Paris, 1859. 2 vol. in –8.

* *Le peintre-graveur hollandais et flamand.* Par J. P. VAN DER KELLEN. Utrecht, 1866. 4to. (Continuation of Bartsch's work.)

* *Le peintre-graveur hollandais et belge du XIXᵉ siècle.* Par T. HIPPERT et JOS. LINNIG. Bruxelle, 1874 (first vol.) et seq. 8vo.

* *Der deutsche Peintre-graveur.* Von A. ANDRESEN. Leipzig, 1864, et seq. 5 vols. 8vo.

* *Die Malerradirer des* 19. *Jahrhunderts.* Von A. ANDRESEN. Leipzig, 1866–1870. 4 vols. 8vo.

* *Die Malerradirer des* 19. *Jahrhunderts.* Von J. E. WESSELY. Leipzig, 1874. 8vo. (Continuation of Andresen's work.)

(*b.*) INDIVIDUAL ARTISTS.

Beredeneerde catalogus van alle de prenten van NICOLAAS BERGHEM . . . beschreven door HENDRICK DE WINTER. Amsterdam, 1767.

Catalogue de l'œuvre d'Abraham Bosse, par GEORGES DUPLESSIS. Paris, 1859. In –8. (From the " Revue Universelle des Arts.")

Éloge historique de Callot, par le P. HUSSON. Bruxelles, 1766. In –4.

A Catalogue and Description of the whole of the Works of the celebrated JACQUES CALLOT . . . by J. H. GREEN (attributed to CLAUSSIN). 1804. 12mo.

Éloge historique de Callot, par M. DESMARETZ. Nancy, 1828. In –8.

Recherches sur la vie et les ouvrages de J. CALLOT, par E. MEAUME. Paris, 1860. 2 vol. in –8.

Œuvre de Claude Gelée, dit le Lorrain, par le comte GUILLAUME DE L. (LEPPEL). Dresde, 1806. In –8, fig. (For the engraved works of Claude Lorrain, see also the " Peintre-graveur " of M. Robert Dumesnil, vol. i., and the "Cabinet de l'Amateur et de l'Antiquaire," by Eugene Piot, vol. ii. pp. 433–466.)

Éloge historique de Claude Gelée, dit le Lorrain, par J. P. VOIART. Nancy, 1839. In –8.

A Description of the Works of the ingenious Delineator and Engraver, WENCESLAUS HOLLAR, disposed into Classes of different Sorts ; with some Account of his Life. By G. VERTUE. London, 1745. 4to. Portr

De la gravure à l'eau-forte et des eaux-fortes de Charles Jacque. By CHARLES BLANC. In the "Gazette des Beaux Arts," vol. ix. p. 193 et seq.

Les Johannot, par M. CH. LENORMANT. Paris (1858). In –8. (From Michaud's " Biographie universelle.")

* *Essay on Méryon, and a Catalogue of his Works,* by FREDERIC WEDMORE. London, Thibaudeau, 1879. (Announced as about to be published.) See also *Méryon and Méryon's Paris,* by F. WEDMORE, in the " Nineteenth Century," for May, 1878.

* *P. Burty's Catalogue of the Etchings of Méryon,* revised from the Catalogue in the " Gazette des Beaux Arts," and translated by Mr. M. B. HUISH, is announced to be published by the London Fine-Art Society.

M^r. O'Connell, Meissonier, Millet, Méryon, Seymour Haden. Articles on these etchers by PHILIPPE BURTY in the " Gazette des Beaux Arts."

Catalogue raisonné des estampes gravées à l'eau-forte par GUIDO RENI, par ADAM BARTSCH. Vienne, 1795. In –8.

Catalogue raisonné de toutes les estampes qui forment l'œuvre de *Rembrandt,* . . . par ADAM BARTSCH. Vienne, 1797. 2 vol. in –8.

A Descriptive Catalogue of the Prints of Rembrandt, by an Amateur (WILSON). London, 1836. In –8.

Rembrandt and his Works, . . . by JOHN BURNET. London, 1859. 4to. Ill.

Rembrandt. Discours sur sa vie et son génie, avec un grand nombre de documents historiques, par le Dr. P. SCHELTEMA, traduit par A. WILLEMS. Revu et annoté par W. BURGER. Bruxelles, 1859. In –8. (From the " Revue universelle des Arts.")

L'Œuvre complet de Rembrandt, remarquablement décrit et commenté par CHARLES BLANC. Paris, 1859. 3 vol. in –8.

* *Rembrandt Harmens van Rijn.* Ses précurseurs et ses années d'apprentissage. Par C. VOSMAER. La Haye, Nijhoff, 1863.

* *Rembrandt Harmens van Rijn.* Sa vie et ses œuvres. Par C. VOSMAER. La Haye, Nijhoff, 1868. (A second, revised edition appeared some years ago.)

* *The Etched Works of Rembrandt.* A Monograph. By FRANCIS SEYMOUR HADEN. With three plates and appendix. London, Macmillan, 1879. Medium 8vo.

* *Descriptive Catalogue* of the Etched Works of *Rembrandt van Rhyn.* With Life and Introduction. By C. H. MIDDLETON. Royal 8vo. London, 1879.

Pictorial Notices; consisting of a Memoir of *Sir Anthony van Dyck,* with a Descriptive Catalogue of the Etchings executed by him. . . . By WILLIAM HOOKHAM CARPENTER. London, 1844. 4to. Portrait.

* *The Works of the American Etchers.* In the "American Art Review."

A CATALOGUE OF
SELECTED DOVER BOOKS
IN ALL FIELDS OF INTEREST

A CATALOGUE OF SELECTED DOVER
BOOKS IN ALL FIELDS OF INTEREST

RACKHAM'S COLOR ILLUSTRATIONS FOR WAGNER'S RING. Rackham's finest mature work—all 64 full-color watercolors in a faithful and lush interpretation of the *Ring*. Full-sized plates on coated stock of the paintings used by opera companies for authentic staging of Wagner. Captions aid in following complete Ring cycle. Introduction. 64 illustrations plus vignettes. 72pp. 8⅝ x 11¼. 23779-6 Pa. $6.00

CONTEMPORARY POLISH POSTERS IN FULL COLOR, edited by Joseph Czestochowski. 46 full-color examples of brilliant school of Polish graphic design, selected from world's first museum (near Warsaw) dedicated to poster art. Posters on circuses, films, plays, concerts all show cosmopolitan influences, free imagination. Introduction. 48pp. 9⅜ x 12¼. 23780-X Pa. $6.00

GRAPHIC WORKS OF EDVARD MUNCH, Edvard Munch. 90 haunting, evocative prints by first major Expressionist artist and one of the greatest graphic artists of his time: *The Scream, Anxiety, Death Chamber, The Kiss, Madonna*, etc. Introduction by Alfred Werner. 90pp. 9 x 12. 23765-6 Pa. $5.00

THE GOLDEN AGE OF THE POSTER, Hayward and Blanche Cirker. 70 extraordinary posters in full colors, from Maitres de l'Affiche, Mucha, Lautrec, Bradley, Cheret, Beardsley, many others. Total of 78pp. 9⅜ x 12¼. 22753-7 Pa. $5.95

THE NOTEBOOKS OF LEONARDO DA VINCI, edited by J. P. Richter. Extracts from manuscripts reveal great genius; on painting, sculpture, anatomy, sciences, geography, etc. Both Italian and English. 186 ms. pages reproduced, plus 500 additional drawings, including studies for *Last Supper*, Sforza monument, etc. 860pp. 7⅞ x 10¾. (Available in U.S. only) 22572-0, 22573-9 Pa., Two-vol. set $15.90

THE CODEX NUTTALL, as first edited by Zelia Nuttall. Only inexpensive edition, in full color, of a pre-Columbian Mexican (Mixtec) book. 88 color plates show kings, gods, heroes, temples, sacrifices. New explanatory, historical introduction by Arthur G. Miller. 96pp. 11⅜ x 8½. (Available in U.S. only) 23168-2 Pa. $7.95

UNE SEMAINE DE BONTÉ, A SURREALISTIC NOVEL IN COLLAGE, Max Ernst. Masterpiece created out of 19th-century periodical illustrations, explores worlds of terror and surprise. Some consider this Ernst's greatest work. 208pp. 8⅛ x 11. 23252-2 Pa. $5.00

DRAWINGS OF WILLIAM BLAKE, William Blake. 92 plates from Book of Job, *Divine Comedy, Paradise Lost,* visionary heads, mythological figures, Laocoon, etc. Selection, introduction, commentary by Sir Geoffrey Keynes. 178pp. 8⅛ x 11. 22303-5 Pa. $4.00

ENGRAVINGS OF HOGARTH, William Hogarth. 101 of Hogarth's greatest works: *Rake's Progress, Harlot's Progress, Illustrations for Hudibras, Before and After, Beer Street and Gin Lane,* many more. Full commentary. 256pp. 11 x 13¾. 22479-1 Pa. $12.95

DAUMIER: 120 GREAT LITHOGRAPHS, Honore Daumier. Wide-ranging collection of lithographs by the greatest caricaturist of the 19th century. Concentrates on eternally popular series on lawyers, on married life, on liberated women, etc. Selection, introduction, and notes on plates by Charles F. Ramus. Total of 158pp. 9⅜ x 12¼. 23512-2 Pa. $5.50

DRAWINGS OF MUCHA, Alphonse Maria Mucha. Work reveals draftsman of highest caliber: studies for famous posters and paintings, renderings for book illustrations and ads, etc. 70 works, 9 in color; including 6 items not drawings. Introduction. List of illustrations. 72pp. 9⅜ x 12¼. (Available in U.S. only) 23672-2 Pa. $4.00

GIOVANNI BATTISTA PIRANESI: DRAWINGS IN THE PIERPONT MORGAN LIBRARY, Giovanni Battista Piranesi. For first time ever all of Morgan Library's collection, world's largest. 167 illustrations of rare Piranesi drawings—archeological, architectural, decorative and visionary. Essay, detailed list of drawings, chronology, captions. Edited by Felice Stampfle. 144pp. 9⅜ x 12¼. 23714-1 Pa. $7.50

NEW YORK ETCHINGS (1905-1949), John Sloan. All of important American artist's N.Y. life etchings. 67 works include some of his best art; also lively historical record—Greenwich Village, tenement scenes. Edited by Sloan's widow. Introduction and captions. 79pp. 8⅜ x 11¼. 23651-X Pa. $4.00

CHINESE PAINTING AND CALLIGRAPHY: A PICTORIAL SURVEY, Wan-go Weng. 69 fine examples from John M. Crawford's matchless private collection: landscapes, birds, flowers, human figures, etc., plus calligraphy. Every basic form included: hanging scrolls, handscrolls, album leaves, fans, etc. 109 illustrations. Introduction. Captions. 192pp. 8⅞ x 11¾. 23707-9 Pa. $7.95

DRAWINGS OF REMBRANDT, edited by Seymour Slive. Updated Lippmann, Hofstede de Groot edition, with definitive scholarly apparatus. All portraits, biblical sketches, landscapes, nudes, Oriental figures, classical studies, together with selection of work by followers. 550 illustrations. Total of 630pp. 9⅛ x 12¼. 21485-0, 21486-9 Pa., Two-vol. set $15.00

THE DISASTERS OF WAR, Francisco Goya. 83 etchings record horrors of Napoleonic wars in Spain and war in general. Reprint of 1st edition, plus 3 additional plates. Introduction by Philip Hofer. 97pp. 9⅜ x 8¼. 21872-4 Pa. $3.75

THE EARLY WORK OF AUBREY BEARDSLEY, Aubrey Beardsley. 157 plates, 2 in color: *Manon Lescaut, Madame Bovary, Morte Darthur, Salome,* other. Introduction by H. Marillier. 182pp. 8⅛ x 11. 21816-3 Pa. $4.50

THE LATER WORK OF AUBREY BEARDSLEY, Aubrey Beardsley. Exotic masterpieces of full maturity: *Venus and Tannhauser, Lysistrata, Rape of the Lock, Volpone,* Savoy material, etc. 174 plates, 2 in color. 186pp. 8⅛ x 11. 21817-1 Pa. $4.50

THOMAS NAST'S CHRISTMAS DRAWINGS, Thomas Nast. Almost all Christmas drawings by creator of image of Santa Claus as we know it, and one of America's foremost illustrators and political cartoonists. 66 illustrations. 3 illustrations in color on covers. 96pp. 8⅜ x 11¼. 23660-9 Pa. $3.50

THE DORÉ ILLUSTRATIONS FOR DANTE'S DIVINE COMEDY, Gustave Doré. All 135 plates from Inferno, Purgatory, Paradise; fantastic tortures, infernal landscapes, celestial wonders. Each plate with appropriate (translated) verses. 141pp. 9 x 12. 23231-X Pa. $4.50

DORÉ'S ILLUSTRATIONS FOR RABELAIS, Gustave Doré. 252 striking illustrations of *Gargantua and Pantagruel* books by foremost 19th-century illustrator. Including 60 plates, 192 delightful smaller illustrations. 153pp. 9 x 12. 23656-0 Pa. $5.00

LONDON: A PILGRIMAGE, Gustave Doré, Blanchard Jerrold. Squalor, riches, misery, beauty of mid-Victorian metropolis; 55 wonderful plates, 125 other illustrations, full social, cultural text by Jerrold. 191pp. of text. 9⅜ x 12¼. 22306-X Pa. $7.00

THE RIME OF THE ANCIENT MARINER, Gustave Doré, S. T. Coleridge. Dore's finest work, 34 plates capture moods, subtleties of poem. Full text. Introduction by Millicent Rose. 77pp. 9¼ x 12. 22305-1 Pa. $3.50

THE DORE BIBLE ILLUSTRATIONS, Gustave Doré. All wonderful, detailed plates: Adam and Eve, Flood, Babylon, Life of Jesus, etc. Brief King James text with each plate. Introduction by Millicent Rose. 241 plates. 241pp. 9 x 12. 23004-X Pa. $6.00

THE COMPLETE ENGRAVINGS, ETCHINGS AND DRYPOINTS OF ALBRECHT DURER. "Knight, Death and Devil"; "Melencolia," and more—all Dürer's known works in all three media, including 6 works formerly attributed to him. 120 plates. 235pp. 8⅜ x 11¼. 22851-7 Pa. $6.50

MAXIMILIAN'S TRIUMPHAL ARCH, Albrecht Dürer and others. Incredible monument of woodcut art: 8 foot high elaborate arch—heraldic figures, humans, battle scenes, fantastic elements—that you can assemble yourself. Printed on one side, layout for assembly. 143pp. 11 x 16. 21451-6 Pa. $5.00

THE COMPLETE WOODCUTS OF ALBRECHT DURER, edited by Dr. W. Kurth. 346 in all: "Old Testament," "St. Jerome," "Passion," "Life of Virgin," Apocalypse," many others. Introduction by Campbell Dodgson. 285pp. 8½ x 12¼. 21097-9 Pa. $7.50

DRAWINGS OF ALBRECHT DURER, edited by Heinrich Wolfflin. 81 plates show development from youth to full style. Many favorites; many new. Introduction by Alfred Werner. 96pp. 8⅛ x 11. 22352-3 Pa. $5.00

THE HUMAN FIGURE, Albrecht Dürer. Experiments in various techniques—stereometric, progressive proportional, and others. Also life studies that rank among finest ever done. Complete reprinting of Dresden Sketchbook. 170 plates. 355pp. 8⅜ x 11¼. 21042-1 Pa. $7.95

OF THE JUST SHAPING OF LETTERS, Albrecht Dürer. Renaissance artist explains design of Roman majuscules by geometry, also Gothic lower and capitals. Grolier Club edition. 43pp. 7⅞ x 10¾ 21306-4 Pa. $3.00

TEN BOOKS ON ARCHITECTURE, Vitruvius. The most important book ever written on architecture. Early Roman aesthetics, technology, classical orders, site selection, all other aspects. Stands behind everything since. Morgan translation. 331pp. 5⅜ x 8½. 20645-9 Pa. $4.50

THE FOUR BOOKS OF ARCHITECTURE, Andrea Palladio. 16th-century classic responsible for Palladian movement and style. Covers classical architectural remains, Renaissance revivals, classical orders, etc. 1738 Ware English edition. Introduction by A. Placzek. 216 plates. 110pp. of text. 9½ x 12¾. 21308-0 Pa. $10.00

HORIZONS, Norman Bel Geddes. Great industrialist stage designer, "father of streamlining," on application of aesthetics to transportation, amusement, architecture, etc. 1932 prophetic account; function, theory, specific projects. 222 illustrations. 312pp. 7⅞ x 10¾. 23514-9 Pa. $6.95

FRANK LLOYD WRIGHT'S FALLINGWATER, Donald Hoffmann. Full, illustrated story of conception and building of Wright's masterwork at Bear Run, Pa. 100 photographs of site, construction, and details of completed structure. 112pp. 9¼ x 10. 23671-4 Pa. $5.50

THE ELEMENTS OF DRAWING, John Ruskin. Timeless classic by great Viltorian; starts with basic ideas, works through more difficult. Many practical exercises. 48 illustrations. Introduction by Lawrence Campbell. 228pp. 5⅜ x 8½. 22730-8 Pa. $3.75

GIST OF ART, John Sloan. Greatest modern American teacher, Art Students League, offers innumerable hints, instructions, guided comments to help you in painting. Not a formal course. 46 illustrations. Introduction by Helen Sloan. 200pp. 5⅜ x 8½. 23435-5 Pa. $4.00

THE ANATOMY OF THE HORSE, George Stubbs. Often considered the great masterpiece of animal anatomy. Full reproduction of 1766 edition, plus prospectus; original text and modernized text. 36 plates. Introduction by Eleanor Garvey. 121pp. 11 x 14¾. 23402-9 Pa. $6.00

BRIDGMAN'S LIFE DRAWING, George B. Bridgman. More than 500 illustrative drawings and text teach you to abstract the body into its major masses, use light and shade, proportion; as well as specific areas of anatomy, of which Bridgman is master. 192pp. 6½ x 9¼. (Available in U.S. only) 22710-3 Pa. $3.50

ART NOUVEAU DESIGNS IN COLOR, Alphonse Mucha, Maurice Verneuil, Georges Auriol. Full-color reproduction of *Combinaisons ornementales* (c. 1900) by Art Nouveau masters. Floral, animal, geometric, interlacings, swashes—borders, frames, spots—all incredibly beautiful. 60 plates, hundreds of designs. 9⅜ x 8-1/16. 22885-1 Pa. $4.00

FULL-COLOR FLORAL DESIGNS IN THE ART NOUVEAU STYLE, E. A. Seguy. 166 motifs, on 40 plates, from *Les fleurs et leurs applications decoratives* (1902): borders, circular designs, repeats, allovers, "spots." All in authentic Art Nouveau colors. 48pp. 9⅜ x 12¼. 23439-8 Pa. $5.00

A DIDEROT PICTORIAL ENCYCLOPEDIA OF TRADES AND INDUSTRY, edited by Charles C. Gillispie. 485 most interesting plates from the great French Encyclopedia of the 18th century show hundreds of working figures, artifacts, process, land and cityscapes; glassmaking, papermaking, metal extraction, construction, weaving, making furniture, clothing, wigs, dozens of other activities. Plates fully explained. 920pp. 9 x 12. 22284-5, 22285-3 Clothbd., Two-vol. set $40.00

HANDBOOK OF EARLY ADVERTISING ART, Clarence P. Hornung. Largest collection of copyright-free early and antique advertising art ever compiled. Over 6,000 illustrations, from Franklin's time to the 1890's for special effects, novelty. Valuable source, almost inexhaustible.
Pictorial Volume. Agriculture, the zodiac, animals, autos, birds, Christmas, fire engines, flowers, trees, musical instruments, ships, games and sports, much more. Arranged by subject matter and use. 237 plates. 288pp. 9 x 12. 20122-8 Clothbd. $14.50

Typographical Volume. Roman and Gothic faces ranging from 10 point to 300 point, "Barnum," German and Old English faces, script, logotypes, scrolls and flourishes, 1115 ornamental initials, 67 complete alphabets, more. 310 plates. 320pp. 9 x 12. 20123-6 Clothbd. $15.00

CALLIGRAPHY (CALLIGRAPHIA LATINA), J. G. Schwandner. High point of 18th-century ornamental calligraphy. Very ornate initials, scrolls, borders, cherubs, birds, lettered examples. 172pp. 9 x 13. 20475-8 Pa. $7.00

ART FORMS IN NATURE, Ernst Haeckel. Multitude of strangely beautiful natural forms: Radiolaria, Foraminifera, jellyfishes, fungi, turtles, bats, etc. All 100 plates of the 19th-century evolutionist's *Kunstformen der Natur* (1904). 100pp. 9⅜ x 12¼. 22987-4 Pa. $5.00

CHILDREN: A PICTORIAL ARCHIVE FROM NINETEENTH-CENTURY SOURCES, edited by Carol Belanger Grafton. 242 rare, copyright-free wood engravings for artists and designers. Widest such selection available. All illustrations in line. 119pp. 8⅜ x 11¼.
 23694-3 Pa. $3.50

WOMEN: A PICTORIAL ARCHIVE FROM NINETEENTH-CENTURY SOURCES, edited by Jim Harter. 391 copyright-free wood engravings for artists and designers selected from rare periodicals. Most extensive such collection available. All illustrations in line. 128pp. 9 x 12.
 23703-6 Pa. $4.50

ARABIC ART IN COLOR, Prisse d'Avennes. From the greatest ornamentalists of all time—50 plates in color, rarely seen outside the Near East, rich in suggestion and stimulus. Includes 4 plates on covers. 46pp. 9⅜ x 12¼. 23658-7 Pa. $6.00

AUTHENTIC ALGERIAN CARPET DESIGNS AND MOTIFS, edited by June Beveridge. Algerian carpets are world famous. Dozens of geometrical motifs are charted on grids, color-coded, for weavers, needleworkers, craftsmen, designers. 53 illustrations plus 4 in color. 48pp. 8¼ x 11. (Available in U.S. only) 23650-1 Pa. $1.75

DICTIONARY OF AMERICAN PORTRAITS, edited by Hayward and Blanche Cirker. 4000 important Americans, earliest times to 1905, mostly in clear line. Politicians, writers, soldiers, scientists, inventors, industrialists, Indians, Blacks, women, outlaws, etc. Identificatory information. 756pp. 9¼ x 12¾. 21823-6 Clothbd. $40.00

HOW THE OTHER HALF LIVES, Jacob A. Riis. Journalistic record of filth, degradation, upward drive in New York immigrant slums, shops, around 1900. New edition includes 100 original Riis photos, monuments of early photography. 233pp. 10 x 7⅞. 22012-5 Pa. $7.00

NEW YORK IN THE THIRTIES, Berenice Abbott. Noted photographer's fascinating study of city shows new buildings that have become famous and old sights that have disappeared forever. Insightful commentary. 97 photographs. 97pp. 11⅜ x 10. 22967-X Pa. $5.00

MEN AT WORK, Lewis W. Hine. Famous photographic studies of construction workers, railroad men, factory workers and coal miners. New supplement of 18 photos on Empire State building construction. New introduction by Jonathan L. Doherty. Total of 69 photos. 63pp. 8 x 10¾.
 23475-4 Pa. $3.00

THE DEPRESSION YEARS AS PHOTOGRAPHED BY ARTHUR ROTH-STEIN, Arthur Rothstein. First collection devoted entirely to the work of outstanding 1930s photographer: famous dust storm photo, ragged children, unemployed, etc. 120 photographs. Captions. 119pp. 9¼ x 10¾.
23590-4 Pa. $5.00

CAMERA WORK: A PICTORIAL GUIDE, Alfred Stieglitz. All 559 illustrations and plates from the most important periodical in the history of art photography, Camera Work (1903-17). Presented four to a page, reduced in size but still clear, in strict chronological order, with complete captions. Three indexes. Glossary. Bibliography. 176pp. 8⅜ x 11¼.
23591-2 Pa. $6.95

ALVIN LANGDON COBURN, PHOTOGRAPHER, Alvin L. Coburn. Revealing autobiography by one of greatest photographers of 20th century gives insider's version of Photo-Secession, plus comments on his own work. 77 photographs by Coburn. Edited by Helmut and Alison Gernsheim. 160pp. 8⅛ x 11.
23685-4 Pa. $6.00

NEW YORK IN THE FORTIES, Andreas Feininger. 162 brilliant photographs by the well-known photographer, formerly with Life magazine, show commuters, shoppers, Times Square at night, Harlem nightclub, Lower East Side, etc. Introduction and full captions by John von Hartz. 181pp. 9¼ x 10¾.
23585-8 Pa. $6.00

GREAT NEWS PHOTOS AND THE STORIES BEHIND THEM, John Faber. Dramatic volume of 140 great news photos, 1855 through 1976, and revealing stories behind them, with both historical and technical information. Hindenburg disaster, shooting of Oswald, nomination of Jimmy Carter, etc. 160pp. 8¼ x 11.
23667-6 Pa. $5.00

THE ART OF THE CINEMATOGRAPHER, Leonard Maltin. Survey of American cinematography history and anecdotal interviews with 5 masters—Arthur Miller, Hal Mohr, Hal Rosson, Lucien Ballard, and Conrad Hall. Very large selection of behind-the-scenes production photos. 105 photographs. Filmographies. Index. Originally Behind the Camera. 144pp. 8¼ x 11.
23686-2 Pa. $5.00

DESIGNS FOR THE THREE-CORNERED HAT (LE TRICORNE), Pablo Picasso. 32 fabulously rare drawings—including 31 color illustrations of costumes and accessories—for 1919 production of famous ballet. Edited by Parmenia Migel, who has written new introduction. 48pp. 9⅜ x 12¼. (Available in U.S. only)
23709-5 Pa. $5.00

NOTES OF A FILM DIRECTOR, Sergei Eisenstein. Greatest Russian filmmaker explains montage, making of Alexander Nevsky, aesthetics; comments on self, associates, great rivals (Chaplin), similar material. 78 illustrations. 240pp. 5⅜ x 8½.
22392-2 Pa. $4.50

HOLLYWOOD GLAMOUR PORTRAITS, edited by John Kobal. 145 photos capture the stars from 1926-49, the high point in portrait photography. Gable, Harlow, Bogart, Bacall, Hedy Lamarr, Marlene Dietrich, Robert Montgomery, Marlon Brando, Veronica Lake; 94 stars in all. Full background on photographers, technical aspects, much more. Total of 160pp. 8⅜ x 11¼. 23352-9 Pa. **$6.00**

THE NEW YORK STAGE: FAMOUS PRODUCTIONS IN PHOTOGRAPHS, edited by Stanley Appelbaum. 148 photographs from Museum of City of New York show 142 plays, 1883-1939. *Peter Pan, The Front Page, Dead End, Our Town,* O'Neill, hundreds of actors and actresses, etc. Full indexes. 154pp. 9½ x 10. 23241-7 Pa. **$6.00**

DIALOGUES CONCERNING TWO NEW SCIENCES, Galileo Galilei. Encompassing 30 years of experiment and thought, these dialogues deal with geometric demonstrations of fracture of solid bodies, cohesion, leverage, speed of light and sound, pendulums, falling bodies, accelerated motion, etc. 300pp. 5⅜ x 8½. 60099-8 Pa. $4.00

THE GREAT OPERA STARS IN HISTORIC PHOTOGRAPHS, edited by James Camner. 343 portraits from the 1850s to the 1940s: Tamburini, Mario, Caliapin, Jeritza, Melchior, Melba, Patti, Pinza, Schipa, Caruso, Farrar, Steber, Gobbi, and many more—270 performers in all. Index. 199pp. 8⅜ x 11¼. 23575-0 Pa. $6.50

J. S. BACH, Albert Schweitzer. Great full-length study of Bach, life, background to music, music, by foremost modern scholar. Ernest Newman translation. 650 musical examples. Total of 928pp. 5⅜ x 8½. (Available in U.S. only) 21631-4, 21632-2 Pa., Two-vol. set $11.00

COMPLETE PIANO SONATAS, Ludwig van Beethoven. All sonatas in the fine Schenker edition, with fingering, analytical material. One of best modern editions. Total of 615pp. 9 x 12. (Available in U.S. only) 23134-8, 23135-6 Pa., Two-vol. set $15.00

KEYBOARD MUSIC, J. S. Bach. Bach-Gesellschaft edition. For harpsichord, piano, other keyboard instruments. English Suites, French Suites, Six Partitas, Goldberg Variations, Two-Part Inventions, Three-Part Sinfonias. 312pp. 8⅛ x 11. (Available in U.S. only) 22360-4 Pa. **$6.95**

FOUR SYMPHONIES IN FULL SCORE, Franz Schubert. Schubert's four most popular symphonies: No. 4 in C Minor ("Tragic"); No. 5 in B-flat Major; No. 8 in B Minor ("Unfinished"); No. 9 in C Major ("Great"). Breitkopf & Hartel edition. Study score. 261pp. 9⅜ x 12¼. 23681-1 Pa. $6.50

THE AUTHENTIC GILBERT & SULLIVAN SONGBOOK, W. S. Gilbert, A. S. Sullivan. Largest selection available; 92 songs, uncut, original keys, in piano rendering approved by Sullivan. Favorites and lesser-known fine numbers. Edited with plot synopses by James Spero. 3 illustrations. 399pp. 9 x 12. 23482-7 Pa. **$9.95**

PRINCIPLES OF ORCHESTRATION, Nikolay Rimsky-Korsakov. Great classical orchestrator provides fundamentals of tonal resonance, progression of parts, voice and orchestra, tutti effects, much else in major document. 330pp. of musical excerpts. 489pp. 6½ x 9¼. 21266-1 Pa. $7.50

TRISTAN UND ISOLDE, Richard Wagner. Full orchestral score with complete instrumentation. Do not confuse with piano reduction. Commentary by Felix Mottl, great Wagnerian conductor and scholar. Study score. 655pp. 8⅛ x 11. 22915-7 Pa. $13.95

REQUIEM IN FULL SCORE, Giuseppe Verdi. Immensely popular with choral groups and music lovers. Republication of edition published by C. F. Peters, Leipzig, n. d. German frontmaker in English translation. Glossary. Text in Latin. Study score. 204pp. 9⅜ x 12¼.
23682-X Pa. $6.00

COMPLETE CHAMBER MUSIC FOR STRINGS, Felix Mendelssohn. All of Mendelssohn's chamber music: Octet, 2 Quintets, 6 Quartets, and Four Pieces for String Quartet. (Nothing with piano is included). Complete works edition (1874-7). Study score. 283 pp. 9⅜ x 12¼.
23679-X Pa. $7.50

POPULAR SONGS OF NINETEENTH-CENTURY AMERICA, edited by Richard Jackson. 64 most important songs: "Old Oaken Bucket," "Arkansas Traveler," "Yellow Rose of Texas," etc. Authentic original sheet music, full introduction and commentaries. 290pp. 9 x 12. 23270-0 Pa. $7.95

COLLECTED PIANO WORKS, Scott Joplin. Edited by Vera Brodsky Lawrence. Practically all of Joplin's piano works—rags, two-steps, marches, waltzes, etc., 51 works in all. Extensive introduction by Rudi Blesh. Total of 345pp. 9 x 12. 23106-2 Pa. $14.95

BASIC PRINCIPLES OF CLASSICAL BALLET, Agrippina Vaganova. Great Russian theoretician, teacher explains methods for teaching classical ballet; incorporates best from French, Italian, Russian schools. 118 illustrations. 175pp. 5⅜ x 8½. 22036-2 Pa. $2.50

CHINESE CHARACTERS, L. Wieger. Rich analysis of 2300 characters according to traditional systems into primitives. Historical-semantic analysis to phonetics (Classical Mandarin) and radicals. 820pp. 6⅛ x 9¼.
21321-8 Pa. $10.00

EGYPTIAN LANGUAGE: EASY LESSONS IN EGYPTIAN HIERO-GLYPHICS, E. A. Wallis Budge. Foremost Egyptologist offers Egyptian grammar, explanation of hieroglyphics, many reading texts, dictionary of symbols. 246pp. 5 x 7½. (Available in U.S. only)
21394-3 Clothbd. $7.50

AN ETYMOLOGICAL DICTIONARY OF MODERN ENGLISH, Ernest Weekley. Richest, fullest work, by foremost British lexicographer. Detailed word histories. Inexhaustible. Do not confuse this with Concise Etymological Dictionary, which is abridged. Total of 856pp. 6½ x 9¼.
21873-2, 21874-0 Pa., Two-vol. set $12.00

A MAYA GRAMMAR, Alfred M. Tozzer. Practical, useful English-language grammar by the Harvard anthropologist who was one of the three greatest American scholars in the area of Maya culture. Phonetics, grammatical processes, syntax, more. 301pp. 5⅜ x 8½. 23465-7 Pa. $4.00

THE JOURNAL OF HENRY D. THOREAU, edited by Bradford Torrey, F. H. Allen. Complete reprinting of 14 volumes, 1837-61, over two million words; the sourcebooks for *Walden*, etc. Definitive. All original sketches, plus 75 photographs. Introduction by Walter Harding. Total of 1804pp. 8½ x 12¼. 20312-3, 20313-1 Clothbd., Two-vol. set $50.00

CLASSIC GHOST STORIES, Charles Dickens and others. 18 wonderful stories you've wanted to reread: "The Monkey's Paw," "The House and the Brain," "The Upper Berth," "The Signalman," "Dracula's Guest," "The Tapestried Chamber," etc. Dickens, Scott, Mary Shelley, Stoker, etc. 330pp. 5⅜ x 8½. 20735-8 Pa. $4.50

SEVEN SCIENCE FICTION NOVELS, H. G. Wells. Full novels. *First Men in the Moon, Island of Dr. Moreau, War of the Worlds, Food of the Gods, Invisible Man, Time Machine, In the Days of the Comet.* A basic science-fiction library. 1015pp. 5⅜ x 8½. (Available in U.S. only)
 20264-X Clothbd. $8.95

ARMADALE, Wilkie Collins. Third great mystery novel by the author of *The Woman in White* and *The Moonstone*. Ingeniously plotted narrative shows an exceptional command of character, incident and mood. Original magazine version with 40 illustrations. 597pp. 5⅜ x 8½.
 23429-0 Pa. $6.00

MASTERS OF MYSTERY, H. Douglas Thomson. The first book in English (1931) devoted to history and aesthetics of detective story. Poe, Doyle, LeFanu, Dickens, many others, up to 1930. New introduction and notes by E. F. Bleiler. 288pp. 5⅜ x 8½. (Available in U.S. only)
 23606-4 Pa. $4.00

FLATLAND, E. A. Abbott. Science-fiction classic explores life of 2-D being in 3-D world. Read also as introduction to thought about hyperspace. Introduction by Banesh Hoffmann. 16 illustrations. 103pp. 5⅜ x 8½.
 20001-9 Pa. $2.00

THREE SUPERNATURAL NOVELS OF THE VICTORIAN PERIOD, edited, with an introduction, by E. F. Bleiler. Reprinted complete and unabridged, three great classics of the supernatural: *The Haunted Hotel* by Wilkie Collins, *The Haunted House at Latchford* by Mrs. J. H. Riddell, and *The Lost Stradivarious* by J. Meade Falkner. 325pp. 5⅜ x 8½.
 22571-2 Pa. $4.00

AYESHA: THE RETURN OF "SHE," H. Rider Haggard. Virtuoso sequel featuring the great mythic creation, Ayesha, in an adventure that is fully as good as the first book, *She*. Original magazine version, with 47 original illustrations by Maurice Greiffenhagen. 189pp. 6½ x 9¼.
 23649-8 Pa. $3.50

UNCLE SILAS, J. Sheridan LeFanu. Victorian Gothic mystery novel, considered by many best of period, even better than Collins or Dickens. Wonderful psychological terror. Introduction by Frederick Shroyer. 436pp. 5⅜ x 8½. 21715-9 Pa. $6.00

JURGEN, James Branch Cabell. The great erotic fantasy of the 1920's that delighted thousands, shocked thousands more. Full final text, Lane edition with 13 plates by Frank Pape. 346pp. 5⅜ x 8½.
23507-6 Pa. $4.50

THE CLAVERINGS, Anthony Trollope. Major novel, chronicling aspects of British Victorian society, personalities. Reprint of Cornhill serialization, 16 plates by M. Edwards; first reprint of full text. Introduction by Norman Donaldson. 412pp. 5⅜ x 8½. 23464-9 Pa. $5.00

KEPT IN THE DARK, Anthony Trollope. Unusual short novel about Victorian morality and abnormal psychology by the great English author. Probably the first American publication. Frontispiece by Sir John Millais. 92pp. 6½ x 9¼. 23609-9 Pa. $2.50

RALPH THE HEIR, Anthony Trollope. Forgotten tale of illegitimacy, inheritance. Master novel of Trollope's later years. Victorian country estates, clubs, Parliament, fox hunting, world of fully realized characters. Reprint of 1871 edition. 12 illustrations by F. A. Faser. 434pp. of text. 5⅜ x 8½. 23642-0 Pa. $5.00

YEKL and THE IMPORTED BRIDEGROOM AND OTHER STORIES OF THE NEW YORK GHETTO, Abraham Cahan. Film *Hester Street* based on *Yekl* (1896). Novel, other stories among first about Jewish immigrants of N.Y.'s East Side. Highly praised by W. D. Howells—Cahan "a new star of realism." New introduction by Bernard G. Richards. 240pp. 5⅜ x 8½. 22427-9 Pa. $3.50

THE HIGH PLACE, James Branch Cabell. Great fantasy writer's enchanting comedy of disenchantment set in 18th-century France. Considered by some critics to be even better than his famous *Jurgen*. 10 illustrations and numerous vignettes by noted fantasy artist Frank C. Pape. 320pp. 5⅜ x 8½. 23670-6 Pa. $4.00

ALICE'S ADVENTURES UNDER GROUND, Lewis Carroll. Facsimile of ms. Carroll gave Alice Liddell in 1864. Different in many ways from final Alice. Handlettered, illustrated by Carroll. Introduction by Martin Gardner. 128pp. 5⅜ x 8½. 21482-6 Pa. $2.00

FAVORITE ANDREW LANG FAIRY TALE BOOKS IN MANY COLORS, Andrew Lang. The four Lang favorites in a boxed set—the complete *Red, Green, Yellow* and *Blue* Fairy Books. 164 stories; 439 illustrations by Lancelot Speed, Henry Ford and G. P. Jacomb Hood. Total of about 1500pp. 5⅜ x 8½. 23407-X Boxed set, Pa. $14.95

HOUSEHOLD STORIES BY THE BROTHERS GRIMM. All the great Grimm stories: "Rumpelstiltskin," "Snow White," "Hansel and Gretel," etc., with 114 illustrations by Walter Crane. 269pp. 5⅜ x 8½.
21080-4 Pa. $3.50

SLEEPING BEAUTY, illustrated by Arthur Rackham. Perhaps the fullest, most delightful version ever, told by C. S. Evans. Rackham's best work. 49 illustrations. 110pp. 7⅞ x 10¾.
22756-1 Pa. $2.50

AMERICAN FAIRY TALES, L. Frank Baum. Young cowboy lassoes Father Time; dummy in Mr. Floman's department store window comes to life; and 10 other fairy tales. 41 illustrations by N. P. Hall, Harry Kennedy, Ike Morgan, and Ralph Gardner. 209pp. 5⅜ x 8½.
23643-9 Pa. $3.00

THE WONDERFUL WIZARD OF OZ, L. Frank Baum. Facsimile in full color of America's finest children's classic. Introduction by Martin Gardner. 143 illustrations by W. W. Denslow. 267pp. 5⅜ x 8½.
20691-2 Pa. $3.50

THE TALE OF PETER RABBIT, Beatrix Potter. The inimitable Peter's terrifying adventure in Mr. McGregor's garden, with all 27 wonderful, full-color Potter illustrations. 55pp. 4¼ x 5½. (Available in U.S. only)
22827-4 Pa. $1.25

THE STORY OF KING ARTHUR AND HIS KNIGHTS, Howard Pyle. Finest children's version of life of King Arthur. 48 illustrations by Pyle. 131pp. 6⅛ x 9¼.
21445-1 Pa. $4.95

CARUSO'S CARICATURES, Enrico Caruso. Great tenor's remarkable caricatures of self, fellow musicians, composers, others. Toscanini, Puccini, Farrar, etc. Impish, cutting, insightful. 473 illustrations. Preface by M. Sisca. 217pp. 8⅜ x 11¼.
23528-9 Pa. $6.95

PERSONAL NARRATIVE OF A PILGRIMAGE TO ALMADINAH AND MECCAH, Richard Burton. Great travel classic by remarkably colorful personality. Burton, disguised as a Moroccan, visited sacred shrines of Islam, narrowly escaping death. Wonderful observations of Islamic life, customs, personalities. 47 illustrations. Total of 959pp. 5⅜ x 8½.
21217-3, 21218-1 Pa., Two-vol. set $12.00

INCIDENTS OF TRAVEL IN YUCATAN, John L. Stephens. Classic (1843) exploration of jungles of Yucatan, looking for evidences of Maya civilization. Travel adventures, Mexican and Indian culture, etc. Total of 669pp. 5⅜ x 8½.
20926-1, 20927-X Pa., Two-vol. set $7.90

AMERICAN LITERARY AUTOGRAPHS FROM WASHINGTON IRVING TO HENRY JAMES, Herbert Cahoon, et al. Letters, poems, manuscripts of Hawthorne, Thoreau, Twain, Alcott, Whitman, 67 other prominent American authors. Reproductions, full transcripts and commentary. Plus checklist of all American Literary Autographs in The Pierpont Morgan Library. Printed on exceptionally high-quality paper. 136 illustrations. 212pp. 9⅛ x 12¼.
23548-3 Pa. $12.50

AN AUTOBIOGRAPHY, Margaret Sanger. Exciting personal account of hard-fought battle for woman's right to birth control, against prejudice, church, law. Foremost feminist document. 504pp. 5⅜ x 8½.
20470-7 Pa. $5.50

MY BONDAGE AND MY FREEDOM, Frederick Douglass. Born as a slave, Douglass became outspoken force in antislavery movement. The best of Douglass's autobiographies. Graphic description of slave life. Introduction by P. Foner. 464pp. 5⅜ x 8½.
22457-0 Pa. $5.50

LIVING MY LIFE, Emma Goldman. Candid, no holds barred account by foremost American anarchist: her own life, anarchist movement, famous contemporaries, ideas and their impact. Struggles and confrontations in America, plus deportation to U.S.S.R. Shocking inside account of persecution of anarchists under Lenin. 13 plates. Total of 944pp. 5⅜ x 8½.
22543-7, 22544-5 Pa., Two-vol. set $12.00

LETTERS AND NOTES ON THE MANNERS, CUSTOMS AND CONDITIONS OF THE NORTH AMERICAN INDIANS, George Catlin. Classic account of life among Plains Indians: ceremonies, hunt, warfare, etc. Dover edition reproduces for first time all original paintings. 312 plates. 572pp. of text. 6⅛ x 9¼.
22118-0, 22119-9 Pa.. Two-vol. set $12.00

THE MAYA AND THEIR NEIGHBORS, edited by Clarence L. Hay, others. Synoptic view of Maya civilization in broadest sense, together with Northern, Southern neighbors. Integrates much background, valuable detail not elsewhere. Prepared by greatest scholars: Kroeber, Morley, Thompson, Spinden, Vaillant, many others. Sometimes called Tozzer Memorial Volume. 60 illustrations, linguistic map. 634pp. 5⅜ x 8½.
23510-6 Pa. $7.50

HANDBOOK OF THE INDIANS OF CALIFORNIA, A. L. Kroeber. Foremost American anthropologist offers complete ethnographic study of each group. Monumental classic. 459 illustrations, maps. 995pp. 5⅜ x 8½.
23368-5 Pa. $13.00

SHAKTI AND SHAKTA, Arthur Avalon. First book to give clear, cohesive analysis of Shakta doctrine, Shakta ritual and Kundalini Shakti (yoga). Important work by one of world's foremost students of Shaktic and Tantric thought. 732pp. 5⅜ x 8½. (Available in U.S. only)
23645-5 Pa. $7.95

AN INTRODUCTION TO THE STUDY OF THE MAYA HIEROGLYPHS, Syvanus Griswold Morley. Classic study by one of the truly great figures in hieroglyph research. Still the best introduction for the student for reading Maya hieroglyphs. New introduction by J. Eric S. Thompson. 117 illustrations. 284pp. 5⅜ x 8½.
23108-9 Pa. $4.00

A STUDY OF MAYA ART, Herbert J. Spinden. Landmark classic interprets Maya symbolism, estimates styles, covers ceramics, architecture, murals, stone carvings as artforms. Still a basic book in area. New introduction by J. Eric Thompson. Over 750 illustrations. 341pp. 8⅜ x 11¼.
21235-1 Pa. $6.95

CATALOGUE OF DOVER BOOKS

GEOMETRY, RELATIVITY AND THE FOURTH DIMENSION, Rudolf Rucker. Exposition of fourth dimension, means of visualization, concepts of relativity as Flatland characters continue adventures. Popular, easily followed yet accurate, profound. 141 illustrations. 133pp. 5⅜ x 8½.
23400-2 Pa. $2.75

THE ORIGIN OF LIFE, A. I. Oparin. Modern classic in biochemistry, the first rigorous examination of possible evolution of life from nitrocarbon compounds. Non-technical, easily followed. Total of 295pp. 5⅜ x 8½.
60213-3 Pa. $4.00

PLANETS, STARS AND GALAXIES, A. E. Fanning. Comprehensive introductory survey: the sun, solar system, stars, galaxies, universe, cosmology; quasars, radio stars, etc. 24pp. of photographs. 189pp. 5⅜ x 8½. (Available in U.S. only)
21680-2 Pa. $3.75

THE THIRTEEN BOOKS OF EUCLID'S ELEMENTS, translated with introduction and commentary by Sir Thomas L. Heath. Definitive edition. Textual and linguistic notes, mathematical analysis, 2500 years of critical commentary. Do not confuse with abridged school editions. Total of 1414pp. 5⅜ x 8½. 60088-2, 60089-0, 60090-4 Pa., Three-vol. set $18.50

Prices subject to change without notice.

Available at your book dealer or write for free catalogue to Dept. GI, Dover Publications, Inc., 180 Varick St., N.Y., N.Y. 10014. Dover publishes more than 175 books each year on science, elementary and advanced mathematics, biology, music, art, literary history, social sciences and other areas.